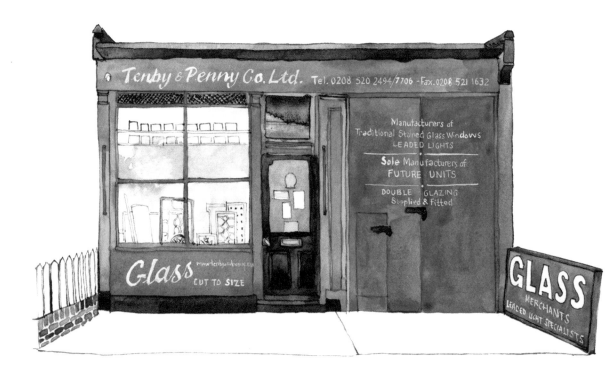

Tenby & Penny, Beulah Road, Walthamstow

SHOPFRONTS of LONDON

Eleanor Crow

Spitalfields Life
Books

BATSFORD

CONTENTS

Eleanor at Pellicci's (photograph Colin O'Brien)

INTRODUCTION

I CHOSE ALL THE SHOPFRONTS in this book because I like the look of them. Many are in East London, where I live, but others caught my eye elsewhere in the city. As I pass through London, I always notice the best-looking shop in any street – the one with the particularly attractive frontage, the inventively designed launderette, the small colourful café, the baker with fine fascia lettering and polished tiles, the ironmonger displaying hardware with wit and ingenuity.

Some are long-standing family businesses, others are more recent enterprises. Some have the cachet of historic architectural detailing in brickwork, masonry or glazing, emphasising the distinctive quality of the shop and the place. Some have a subtle window display, others are flamboyant. In each case, these shopfronts serve the purpose for which they are intended, drawing the attention of the potential customer.

London is comprised of many small communities and, commonly, each one has a terrace of useful shops at the centre. Despite the ubiquity of supermarkets, mini-markets and larger multi-purpose shops, and despite the ease of internet shopping, these small shops persist because of the density of the local population and the convenience of their location. They furnish our wish and whim for any small portable item – a prime cut of beef or an Eccles cake, a garden rake or a fillet of plaice. Or they may simply offer a friendly place to sit and drink a cup of tea after a trip to the market.

Yet they are more than merely useful businesses. Where great care has been taken over their appearance and where the shopkeepers have won many loyal customers, these shops deliver an invaluable community service that cannot be equalled by more impersonal forms of shopping. A diverse collection of small shops lends distinction to any location, conjuring the street life that manifests the identity of the place, both serving a human purpose and revealing that the residents care about their neighbourhood. As well as drawing their trade from the immediate vicinity, these small shops may also acquire reputations that bring customers from further afield.

I have shopped in the shops in this book, not just admiring them from the outside. My selection is personal but it is also intended as a record, aspiring to capture the everyday in the spirit of the 'Recording Britain' project in the last century. I have discovered that my shopfront paintings resonate with many different people, whether they know the particular shop in the picture or not. Somehow, we all share a memory of a similar small shop, whether our roots are rural or urban, whether we come from Britain or overseas, or whether we descend from a family inhabiting the same part of London for generations.

Perhaps unsurprisingly, public affection for small shops – particularly those that have survived for a great many years – is partly because we feel these shops belong to us. They are landmarks on our daily journeys and their presence on the street offers a visual and emotional anchor in an ever-changing cityscape. They are familiar points of reference in a mutable world. As the city skyline alters beyond recognition, the presence of these premises built on a human scale brings us pleasure, even as all around us the buildings, sights and perspectives of the city are eradicated or transformed.

Most of the shops in this book are still open, but some have closed since I painted them or they have passed to a new generation of owners. Working on my paintings, I learnt about shopkeeping and grew curious of the circumstances that might cause a shop to flourish or die. To open a small shop is a tremendous challenge, requiring a grasp of business and a knowledge of the trade, skill in juggling finances to pay for stock, tax, rents and rates, dexterity in managing supply chains, parking restrictions, customer demands and effective stock management. All this has to be achieved while safeguarding against theft or wastage of perishable goods. Numerous factors may shape the fortunes of the small shopkeeper. Some are personal and some are environmental – customer demographics, economic fluctuations, urban planning and government policy on rent and rates all play their part.

When a small shop closes, any of these elements may have contributed, but equally, the shopkeeper may simply wish to retire or move on. A closure may not indicate that anything is amiss, even if we mourn the loss of a favourite shop. Everything is subject

to change, but when a viable business is brought down by government policy or escalating costs, this is the outcome of an unfair disadvantage for the small shopkeeper. All neighbourhoods in London reflect the tension between preservation and change, but I hope these small shops will remain as they are, since they are both beautiful and useful, and they cater for all budgets.

Most of all, this book is a celebration of the small neighbourhood shop. Those that are here and now, and some with a long and illustrious past. Whether you live in Paddington or in Plaistow, Mayfair or Mile End, Camberwell or Clerkenwell, it is the small shops that manifest the character of any community.

Over the years, London's classic cafés have been well documented. From the beginning of the last century onwards, many were opened by Italian immigrants. Historically, London has always enjoyed tea rooms but the post-war economic boom engendered a new flowering of café culture. Many of these Italian café owners possessed a bold style, opening shops in ice-cream colours with Vitrolite fascias and three-dimensional chrome lettering. E. Pellicci is the capital's most notable example and one of the few where the Art Deco interior has remained to this day.

Eliza Acton, in her *English Bread Book* of 1857, noted that the cost of bakery-bought bread took up most of a family's weekly income. We can be grateful that this is not currently the case and also for the twentieth-century laws that ended the nineteenth-century practice of adulterating bread flour with harmful substances to increase profitability. By contrast, many of today's bakers are passionate about the quality of their produce. The majority of those depicted here bake their wares on the premises and there has been a recent increase in the number of shops, even as the vogue for home baking continues unabated.

British butchers have enjoyed an unlikely renaissance too, due to an increased interest in provenance and a suspicion of processed meat in the light of the recent horse meat scandal. Consequently, customers are now willing to spend more to buy better quality meat despite the presence of a nearby supermarket. A butcher can sell a range of cuts for all budgets, as well as offering advice on how to prepare and cook the meat. The rise of the

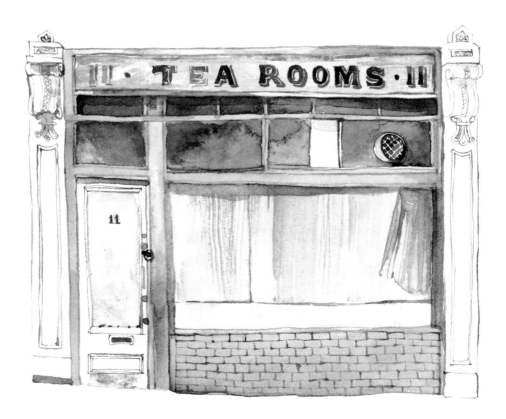

Tea Rooms, Museum Street, Holborn; my first painting of a shopfront.

celebrity chef has also contributed, encouraging people to seek out specialist and traditional butchers, and to buy meat in the old-fashioned way.

My selection of fish shops encompasses fishmongers, fish & chip shops, and eel, pie & mash shops. In common with butchers, fishmongers have also benefitted from the new food culture, offering fresh seasonal produce with a clear provenance. They will readily prepare and scale fish to requirement, providing expert advice and culinary tips. I have selected a few classic fish & chip shops, each with its own character in the style of its facade and interior. Eel & pie shops are inextricably bound up with the cultural identity of the East End. The stylish ceramic tiles and snazzy lettering of these shopfronts, together with their historic interior detailing, make these some of London's most cherished eating places.

I have included both grocers and florists within my chapter of greengrocers. In the nineteenth century, there was a clear distinction, with the former selling provisions and the latter fruit and vegetables. Many now sell both, diversifying to suit their customers' needs.

I grant that the term 'dairy shops' may appear archaic but I have become intrigued by the rise of the specialist cheese shop, many originating as market stalls or opened by restaurateurs with expert knowledge of cheese. By contrast, most of the historic dairies that are still visible around London have often been turned to other uses, with their original tiling and signs still in place.

Some of the most successful and long-lasting small shops are chemists. It is significant that strict rules govern location and competition, protecting an existing viable pharmacy business from the arrival of a new competitor. It is a policy that results in there being a chemist within a short distance of most residential areas, and everyone benefits from this. Longevity is a marker of success in the world of shops and I was delighted by the large number of chemists retaining their historic frontages.

Despite predictions that washing machines at home would destroy them, launderettes have survived. I cherish the inventive signage and skilfully executed typography of many traditional

launderettes and am always saddened when crude new plastic signs replace stylish lettering of an earlier time.

The inventive displays and ingenious signage of ironmongers make these some of my favourite shopfronts. Hardware supplies are mostly non-perishable and not subject to the vagaries of fashion, so the stock can be held for longer than other traders, awaiting the moment when a customer arrives. The service in many ironmongers' shops is greatly superior to any website, offering expert do-it-yourself advice and checking replacement parts against broken fittings for size and type. In the case of a household emergency, a quick trip to your local hardware shop is a better bet than either waiting for a delivery or driving off to a huge warehouse that may not actually have what you need.

Under the heading 'paper goods', I have grouped those shops whose goods are made of paper, whether stamps, art supplies, market sundries or books. This may sound inappropriate when applied to a bookshop, yet early booksellers often functioned as printers and publishers. Bookshops have frequently sold stationery and art materials, and antiquarian book dealers often also sell prints.

What each one of these shops and their shopfronts in this book has in common is their particularity. They bear a distinctive appearance that enhances our streets and encourages us to visit and shop there. Perhaps my book will encourage those who run these wonderful shops to cherish what they have, and those with newly created shops to invest in frontages with equal amounts of care paid to the typography and the design, down to the last detail. Their window displays encourage us to turn from passers-by into customers, so that we may continue to support these small businesses that serve our communities.

CAFÉS

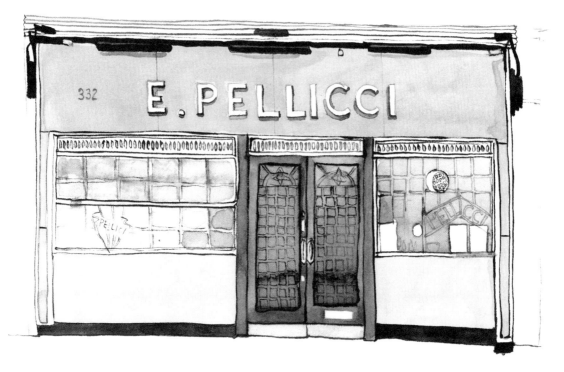

E. Pellicci, Bethnal Green Road, Bethnal Green

THIS SMALL friendly café has been owned by the Pellicci family since 1900. With its appealing facade of chrome-lined primrose Vitrolite panels, three-dimensional typography and fine decorative detailing, it is a testament to the enduring qualities of thoughtful shop design. The interior features Art Deco marquetry by cabinet maker Achille Cappoci from 1946, and the premises are Grade II listed. Most importantly, the business thrives because the Pellicci family knows how to keep their customers happy – whether diehard locals, passing celebrities or tourists on a pilgrimage – with their winning combination of wholesome food, exemplary service and entertaining banter.

DESPITE BEING closed for years, the Art Deco frontage of the Savoy Café in Hackney was still much admired. The reason so many cafés in London were called 'Savoy' was because they were all opened by Italians who had worked in the kitchens at the Savoy hotel. This one was such a rare survival, with its Vitrolite panels and unusual ice-cream serving hatch, that it deserved to be protected. Unfortunately, the current occupiers were permitted to destroy all this historic detailing for the sake of an inferior design. It is a real pity that no one chose to revive the café in its classic guise, given the popularity of the original frontage.

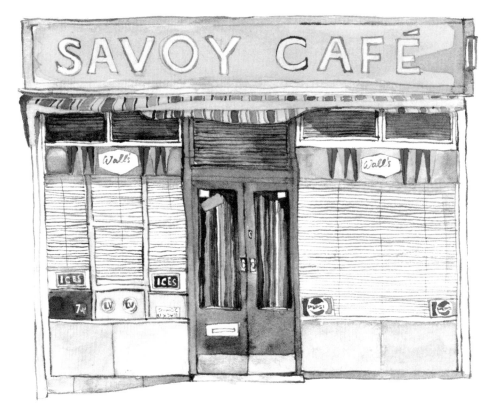

Savoy Café, Graham Road, Hackney

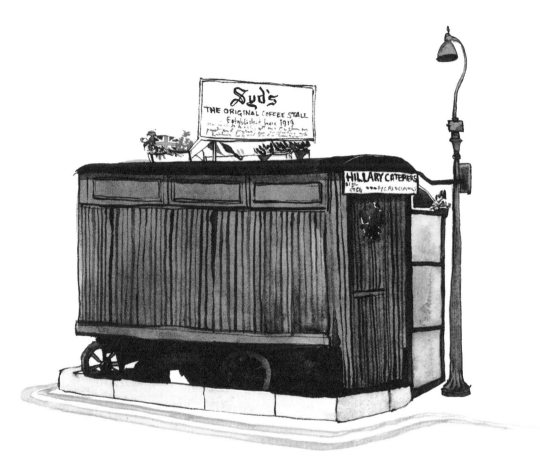

Syd's, Calvert Avenue, Shoreditch

LONDON'S OLDEST coffee stall has been open a century and is still run by Sydney Tothill's granddaughter, Jane. This mahogany refreshment stall is one of my favourite London landmarks. It has only moved from its pitch once, to feature in *Ebb Tide* starring Chili Bouchier in 1931. The stall opened twenty-four hours of the day during World War II, when the War Office brought Syd's son (also called Syd) back from a secret mission to ensure the supply of hot tea to the ambulance and fire brigades during the London Blitz after Syd senior was traumatised by a bomb that exploded nearby.

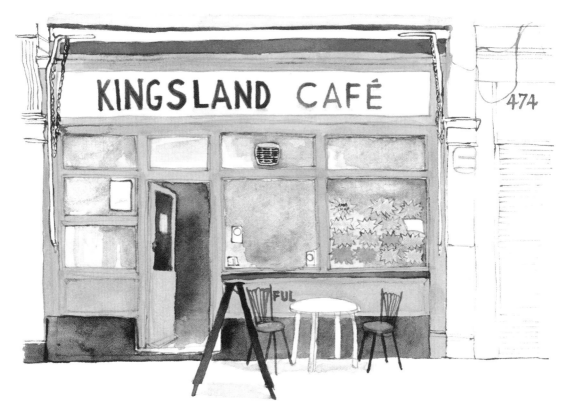

Kingsland Café, Kingsland Road, Dalston

RECENTLY CLOSED, this café was known as Lusardi's Café until 1983 when the word 'Kingsland' was ignominiously substituted for 'Lusardi's'. It was opened as Lusardi's Confectionary Shop by Luigi Lusardi in 1915, which became Lusardi's Café by 1948. A classic café with blue walls and formica tables, it was the array of fluorescent stars in the window that caught my eye, contrasting dramatically with the cheerful yellow woodwork and inviting open door.

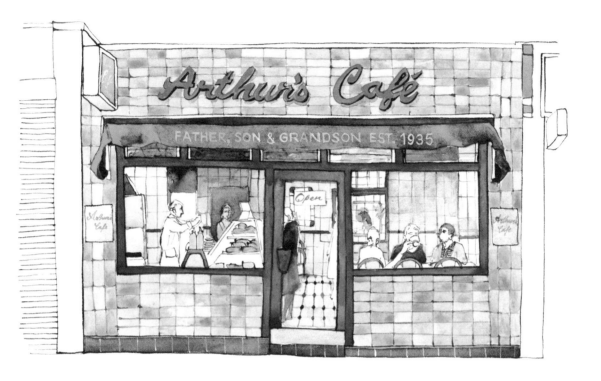

Arthur's Café, Kingsland Road, Dalston

ARTHUR WOODHAM opened his own café in 1948, having previously worked in his father's café just down the road. His father was also called Arthur and ran a café named Arthur's Café. Young Arthur ran his for seventy years until the age of ninety, along with his wife Eileen and grandson James in recent years. Spotless and serving up home-cooked breakfasts followed by traditional lunches with hand-cut chips, this celebrated destination was frequented by loyal customers for seven decades until its recent closure. I painted the café early one morning before it opened, catching a quiet time without traffic and passers-by to obstruct my view. I admired the shaped wooden door handle and the wire grilles in bronze above the windows that matched the warm yellow tiles. I returned later to paint the café when it was open, although I cheated and included myself standing at the counter, ordering a well-earned lunch.

THIS TRADITIONAL neighbourhood café on the corner of Dalston Lane and Ashwin Street, furnished with banquettes and formica-topped tables, was run by Turkish proprietors Dudu and Erkan Aksu – who were more widely known as Mary and Ali – for fifteen years. They hoped to renew the lease but were not offered the opportunity and it closed in 2015. Previously, the café had been run by one family for thirty years as the Beefeater Café, with a cream Vitrolite sign declaring 'Super Service – No 9 Refreshments'. Today it is much missed by local residents because it provided an invaluable focus for the community with affordable fare and a friendly welcome. I enjoyed the combination of pea-green and yellow woodwork against the traditional brown glazed tiles on either side of the door, as well as the hearty fry-ups served inside.

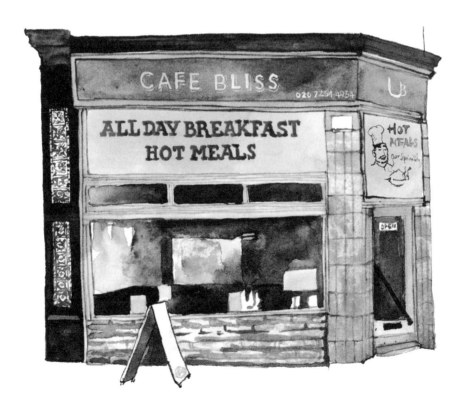

Café Bliss, Dalston Lane, Dalston

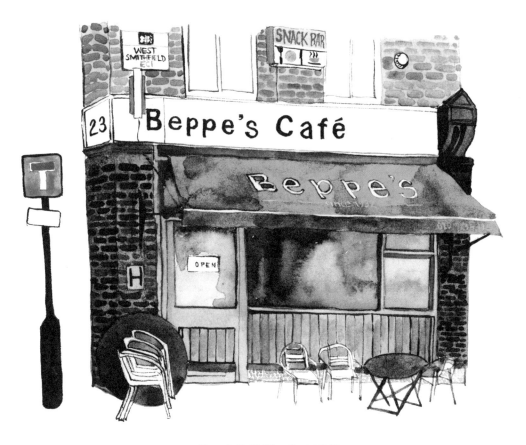

Beppe's Café, West Smithfield

ANOTHER CLASSIC London café, much loved for its atmosphere and Italian heritage. The deep green tiling, cosy booths and wooden counter are all cherished by those in search of a fry-up or a warming cup of coffee in an establishment proud of its historic fixtures and fittings. As I stood on the pavement with my sketchbook in hand, a customer dashed outside thinking I was a traffic warden. This is one of the few cafés where you can park for long enough to pick up a coffee if you are quick.

Grab & Go, Blackhorse Lane, Walthamstow

Billy Bunters Snack Bar, Mile End Road, Whitechapel

GINA AND Philip Christou's Hungarian restaurant was the very first café that caught my eye in the East End, with its scalloped, green-painted frontage and lace curtains. From 1961, Gina and Philip ran a café on Brick Lane before they came here, working together for nearly fifty years until Philip's death in 2012. In their final days, they opened the restaurant just on Sundays to serve roast lunches to the pensioners, fly pitchers and market traders who were their long-term patrons. In the East End Philip and Gina became renowned for their generous spirit and kindness to staff and customers alike.

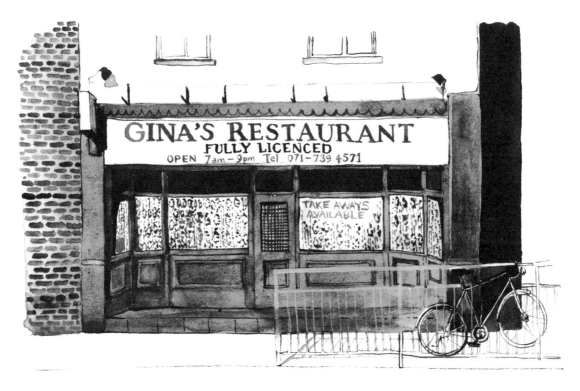

Gina's Restaurant, Bethnal Green Road, Shoreditch

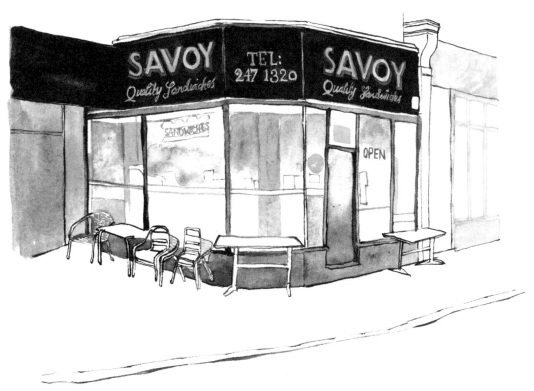

Savoy, Norton Folgate, Spitalfields

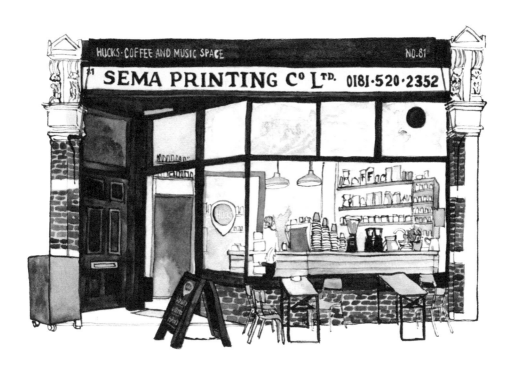

Hucks Coffee and Music Space, Grove Road, Walthamstow

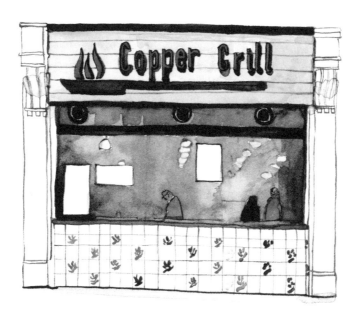

Copper Grill, Eldon Street, Liverpool Street

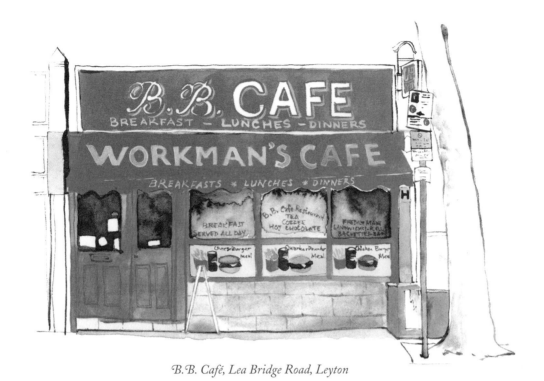

B.B. Café, Lea Bridge Road, Leyton

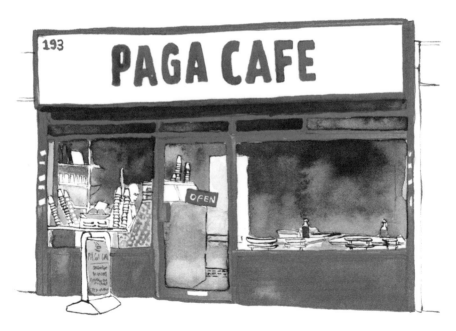

Paga Café, Lea Bridge Road, Walthamstow

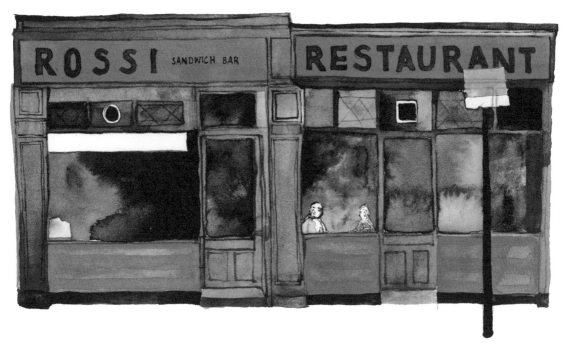

Rossi Restaurant, Hanbury Street, Spitalfields

THIS FAMOUS establishment was opened in the fifties by the Rossi family, who came from Italy and ran it for over forty years, serving porters at the Spitalfields Market. The next owners, Harold and Jenny Londono, from Colombia, kept the premises in good shape and managed this popular café for nine years until they were refused renewal of the lease in 2010. The original features were all torn out and it is now a retro-styled fish and chip shop.

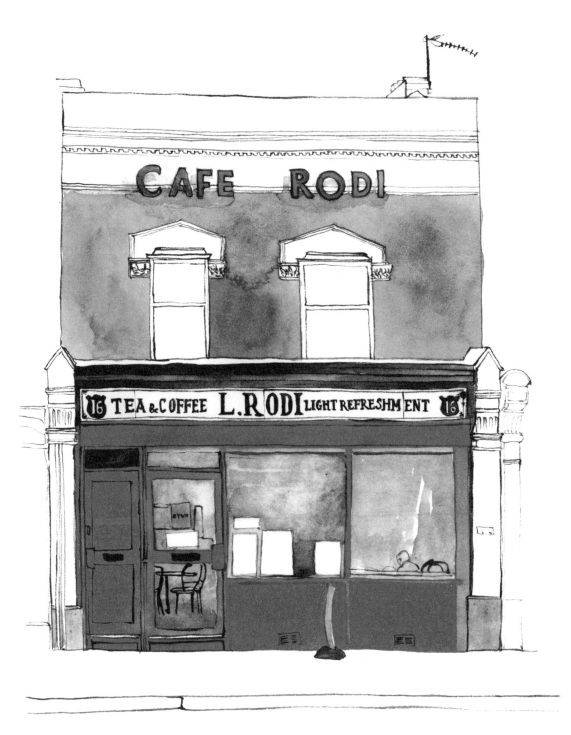

Café Rodi, Blackhorse Lane, Walthamstow

AT LENNIES, the arched frames of the windows and doors and the glazed terracotta tiling are part of the Arts and Crafts architecture of the Boundary Estate in Shoreditch. The hand-painted commercial script on the fascia was added when the café was taken over in the nineties by Mama Irene, a Malaysian-Thai chef, who came to this country in 1958. A confirmed East London resident, she loved the community atmosphere and the way people looked out for each other in the neighbourhood. Lennies opened as a café by day and a Thai restaurant by night, building up a loyal following by offering a valuable service at a time when the area had few late-opening cafés.

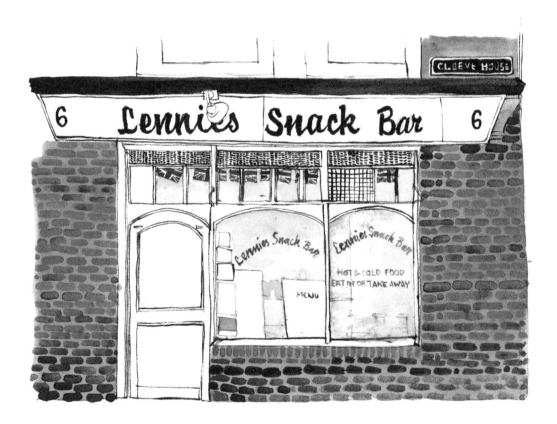

Lennies Snack Bar, Calvert Avenue, Shoreditch

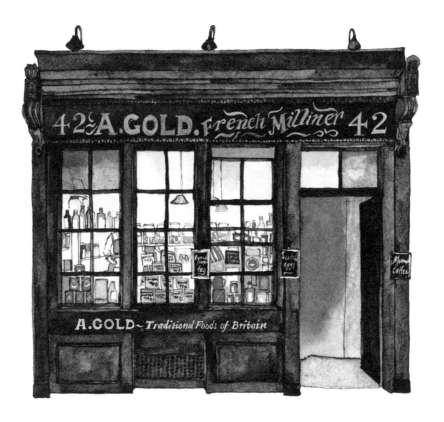

A. Gold, Brushfield Street, Spitalfields

THE FAME of this shop lies in the much-photographed fascia, proclaiming 'A. Gold. French Milliner' in elegant italics. Annie Gold and her husband Jacob were of Polish-Russian origin and she ran her millinery business here at 42 Brushfield Street from 1889 to 1892, living above the shop. In the nineteenth century, this street in Spitalfields comprised sixty-five small businesses, which included a watchmaker, cheesemonger, dining rooms, confectioners, a furrier, fried fish dealer and an undertaker. Yet when I painted this, it was the last independent shop on the street, hemmed in by chains.

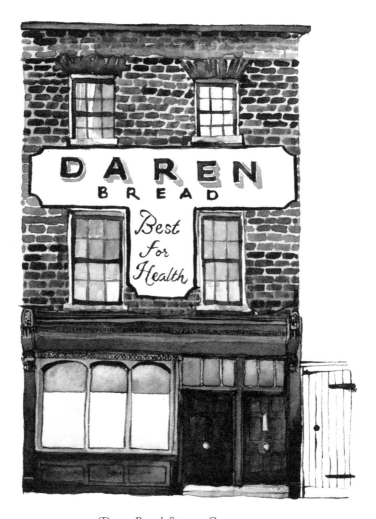

Daren Bread, Stepney Green

THIS IS a ghost sign on a house in Stepney that has become a popular landmark with local people. Like Hovis, Daren Bread declared its health-giving presence on the walls of bakeries that made loaves from their flour under license. Founded in 1892, Daren Flour took their name from the River Darent which powered their mill in Dartford, Kent, until they merged with Hovis in the thirties.

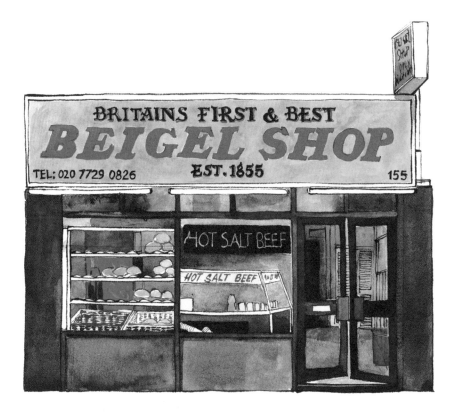

Beigel Shop, Brick Lane

THERE ARE two twenty-four-hour beigel bakeries on Brick Lane almost next door to each other. Often seen as rivals, each draws passionate loyalty from customers who believe their preference to be superior. Just in case you wondered, I chose to paint this one because it is the most visually interesting. These shops are a lively reminder of the Jewish community that once occupied these streets, before migrating to the suburbs in the last century. Today many nationalities can be seen queueing for beigels here at all hours of the day and night.

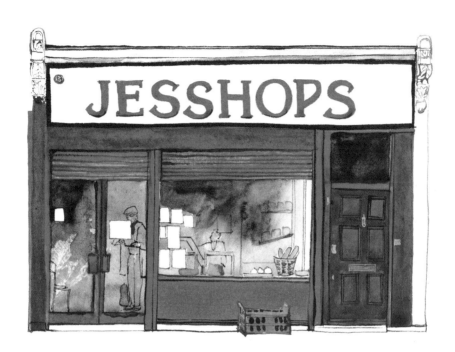

Jesshops, Newington Green Road, Newington Green

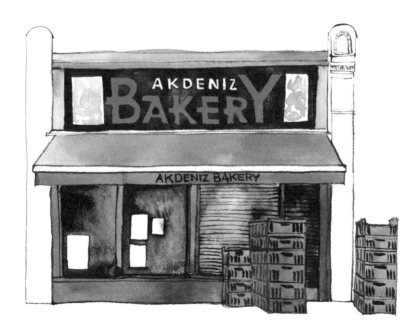

Akdeniz Bakery, Stoke Newington High Street, Stoke Newington

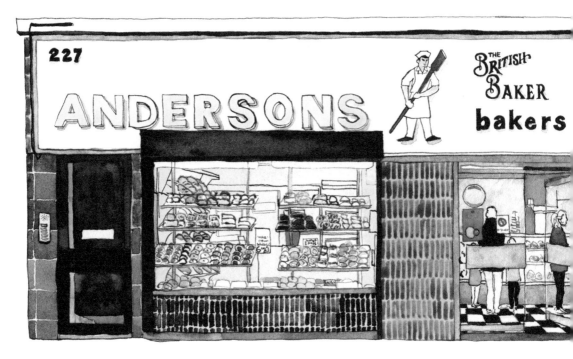

Andersons, Hoxton Street, Hoxton

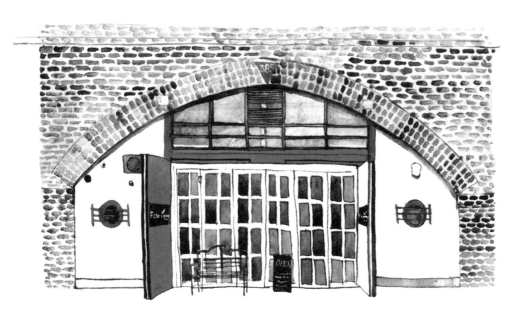

Fabrique, Geffrye Street, Hoxton

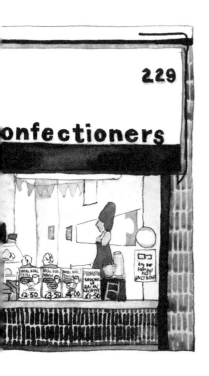

FROM 1975, this was a thriving, lively bakery in Hoxton Market. I was attracted by the graphic quality of the tiled frontage, the chunky lettering and the image of the little baker wielding his wooden peel on the fascia. The Anderson family only recently sold their business after 160 years of baking on Hoxton Street and Monty's Deli now trades from here, championing a fashionable revival in salt beef and pastrami.

FOUNDED IN 2011 by Ben Mackinnon as a community bakery and café, the E5 Bakehouse mills its own organic flour on site, offers bread-making classes, runs inspiring social projects and delivers superlative baking by bicycle to local shops and restaurants.

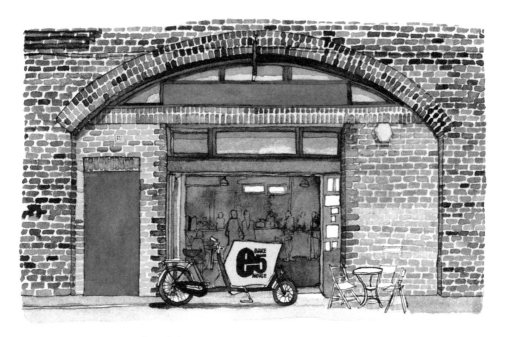

E5 Bakehouse, Mentmore Terrace, London Fields

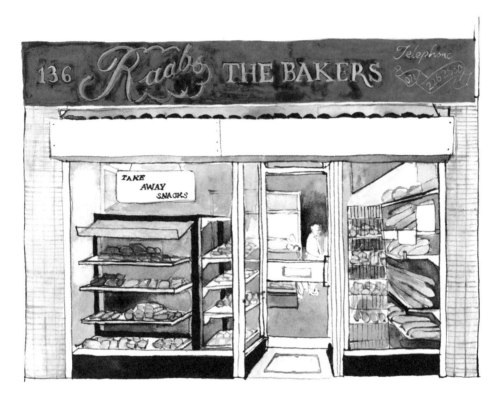

Raab's The Bakers, Essex Road, Islington

RAAB'S BEGAN in 1948 in Dalston but moved to Islington in the seventies. As a family business, where everything is made on site to a dependably high quality, they enjoy many loyal customers, some of whom still make the journey from Dalston to Islington for their baked goods. The Star Bakery (*opposite*) was where Raab's opened in 1948. For years after it closed, this terrace of small shops among the surrounding tall Georgian and Victorian buildings was covered with hoardings while its future was contested. Not long before demolition commenced, the Star Bakery sign disappeared, and I hope someone saved it for posterity rather than letting it be destroyed.

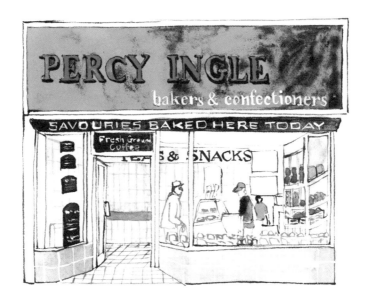

Percy Ingle, Lea Bridge Road, Walthamstow

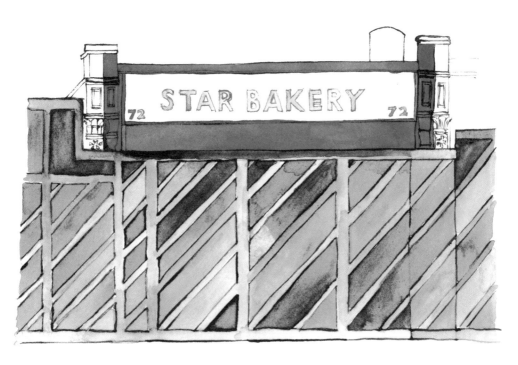

Star Bakery, Dalston Lane, Dalston

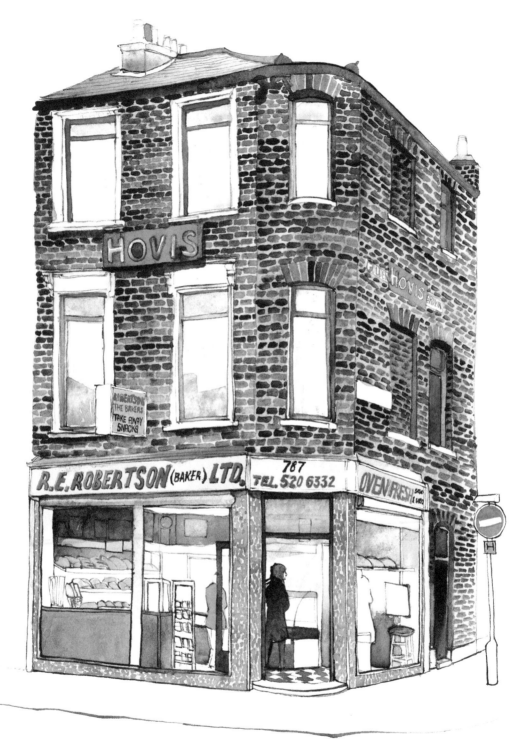

R. E. Robertson, Lea Bridge Road, Walthamstow

RON E. ROBERTSON opened his bakery shop (*opposite*) in 1947 and it was run by his son Clive until it closed in 2013. I painted the whole building because I love every detail of this place: the bold typography with its forward-leaning red three-dimensional capital letters on cream glazed panels, the historic Hovis signs, which are visible from afar in vivid green and gold, the cheerful mid-blue of all the painted window frames and pipework, the intricate mosaic of turquoise and yellow tiles under the shop windows through which could be seen heaped shelves of bread and cakes, and the traditional black and white floor tiles. This busy shop was on a main road, visible to all who passed, witnessing the spectacle of bakers and customers going about their daily trade. The 'No Entry' sign strikes a poignant note, since its introduction by the council meant that the many loyal customers who commuted this way could no longer turn into the side street and park to buy a loaf or some pastries on their journey between London and Essex.

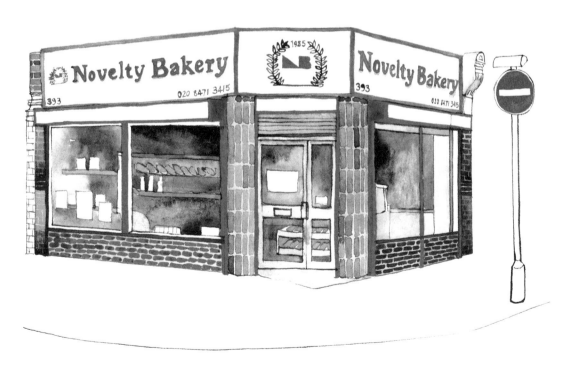

Novelty Bakery, High Street North, East Ham

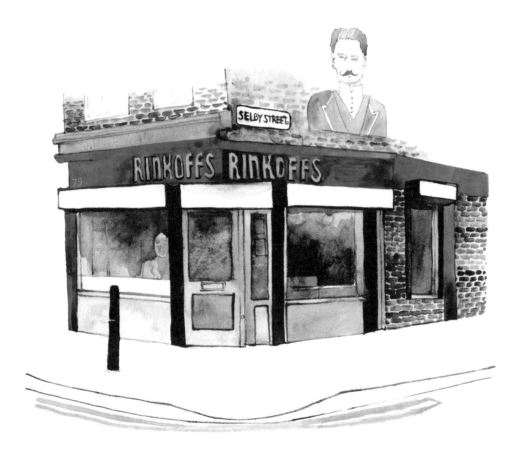

Rinkoffs, Vallance Road, Whitechapel

THIS FOURTH-GENERATION family business was established in 1911 by Hyman Rinkoff, who came from Kiev in 1906. He opened a bakery in Old Montague Street and this one in Vallance Road, which runs between Whitechapel and Bethnal Green. He is commemorated here with a mural of his portrait overlooking his creation.

BUTCHERS

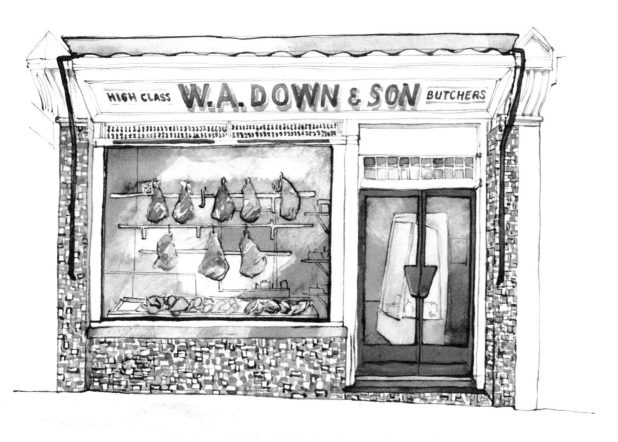

W. A. Down & Son, The Slade, Plumstead

WHILE EXPLORING south-east London, I came upon a run of small shops at The Slade in Plumstead. The gem was this splendid butcher, sporting a mid-century mosaic in white, blue and grey, an original ventilation grille, bright red doors and attractive sign-writing. Owner David Down ran the shop for more than fifty years after leaving school in 1960, taking over from his father Bill, who died in 1963. Regrettably, it has now shut and, although The Slade still boasts a baker, chemist, newsagent and optician, none has such a beautiful shopfront.

ESTABLISHED OVER half a century, this traditional butcher (*opposite*) usually has a window piled high with artfully displayed meat and sausages made on the premises, but I painted it just after they closed for the day when there was hardly anything left. Hussey's is part of a run of small shops on Wapping Lane, including a dry-cleaner, launderette, newsagent and greengrocer. I relish the red tiling and stylish choice of typeface on the signage above this shop.

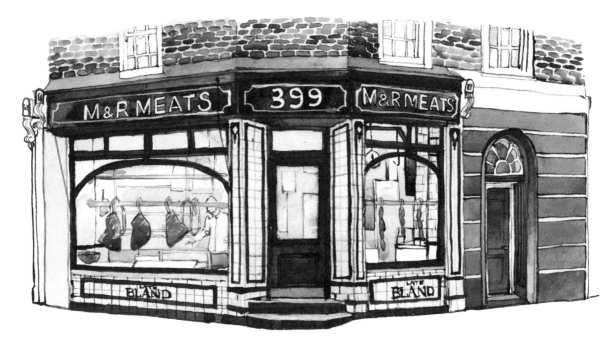

M & R Meats, St John Street, Clerkenwell

I HAD always admired this tiled nineteenth-century corner shop in Clerkenwell and was delighted that the new owners, Turner & George, saw the advantage in retaining the original frontage. Previously, the place was rarely open because the owners were Smithfield traders who mostly supplied meat to restaurants. Although the current owners are also involved in wholesale, it is now trading as a proper butchers shop again.

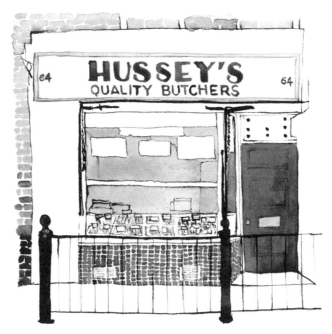

Hussey's, Wapping Lane, Wapping

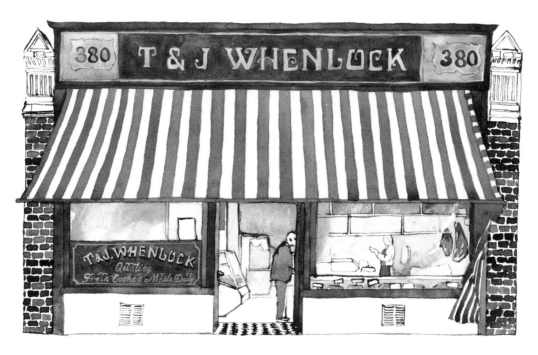

T & J Whenlock, Barking Road, Plaistow

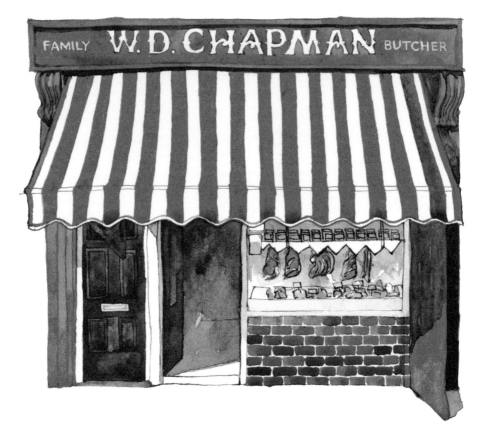

W. D. Chapman, High Road, Woodford Green

W. D. CHAPMAN is a third-generation butchery business, running since the eighteen-nineties from this parade of small shops in Woodford Green, which once supported four butchers' shops. Richard Chapman, grandson of the founder, retired in 2015 at the age of seventy-five but his siblings have continued to work for the new owners and the business thrives.

THIS DRAWING shows an uncharacteristically short queue. Often the line of customers extends all the way down the street, which is always a good sign – revealing that the meat is worth the wait. I cherish this frontage, with its mid-century script in red on a glazed background, red canopy and grinning butcher mannequin, welcoming customers inside.

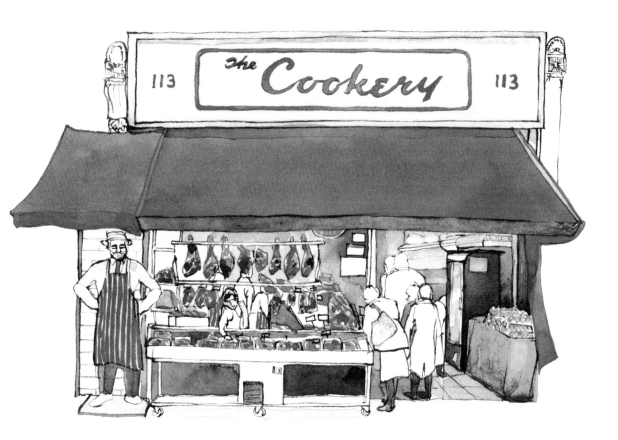

The Cookery, Stoke Newington High Street, Stoke Newington

MICK NORKETT has been in butchery for almost fifty years, specialising in sausages. He sells to top restaurants as well as supplying enthusiastic queues of customers at this popular Walthamstow Village location, celebrated for its small shops and cafés. Although his shop has recently closed, Mick continues to work in semi-retirement from his Waltham Abbey wholesale operation.

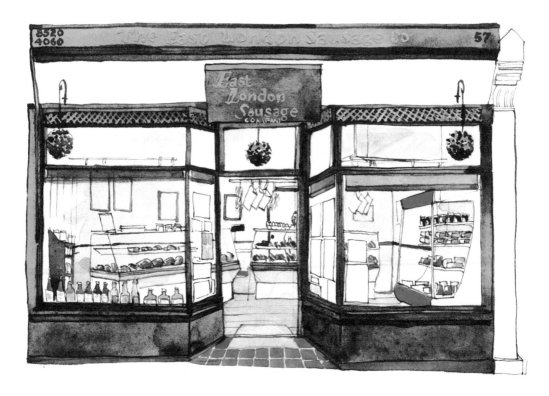

The East London Sausage Company, Orford Road, Walthamstow

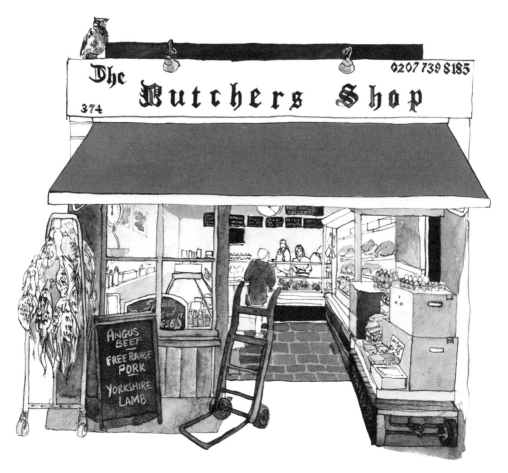

The Butchers Shop, Bethnal Green Road, Bethnal Green

WHEN PETER Sargent took over his shop in 1983 there were eight butchers in Bethnal Green, but now he is the last one standing. It seemed like Peter might go the way of the rest, until he achieved tabloid fame by placing a sign across the road in front of his shop. Directed at those on their way to the supermarket, it said, 'Have a look in butcher's opposite before you go in Tesco.' Peter says that the supermarket threatened legal action, until it was revealed that Tesco had been selling horsemeat and Peter left a bale of hay outside his shop.

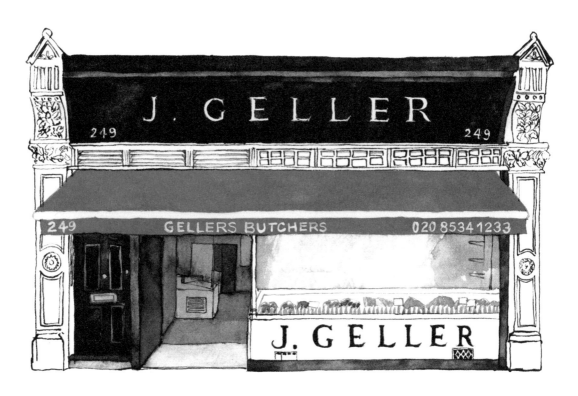

J. Geller, High Road, Leytonstone

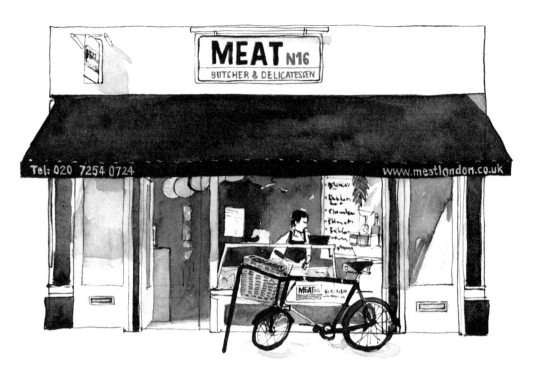

Meat N16, Church Street, Stoke Newington

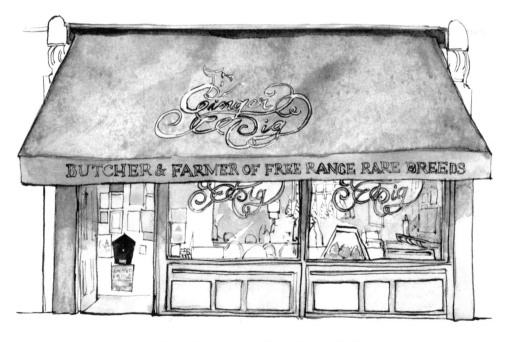

Ginger Pig, Lauriston Road, Victoria Park

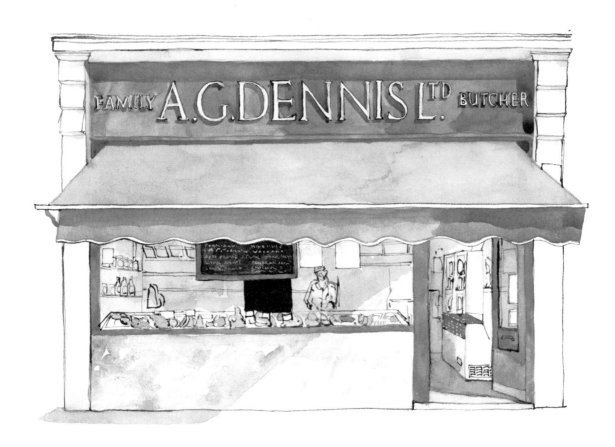

A. G. Dennis, High Street, Wanstead

A.G. DENNIS served Wanstead's busy High Street for over ninety years and, when he closed, residents were so keen to retain a butcher's shop that they petitioned The Ginger Pig to take over, recognising that a smaller business would no longer be able to pay the high rent. New manager Liam Moore trained as a butcher from the age of sixteen in Galway and his shop enjoys strong support locally, with many travelling from afar.

FISH SHOPS

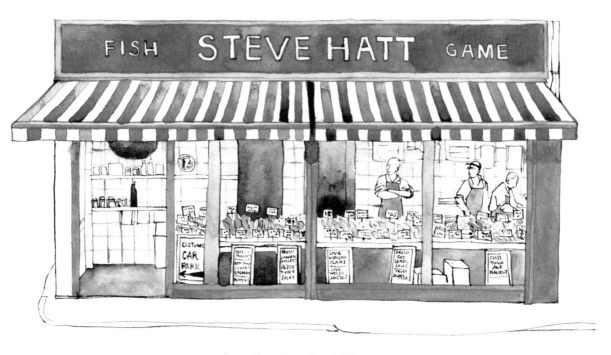

Steve Hatt, Essex Road, Islington

STEVE HATT'S fish shop has been a family-run institution on the Essex Road in Islington since 1895. The shopfront has changed many times through the decades and I have immortalised its most recent incarnation in blue. Customers queue down the street here on Fridays and Saturdays for the quality fish and expertise of the staff.

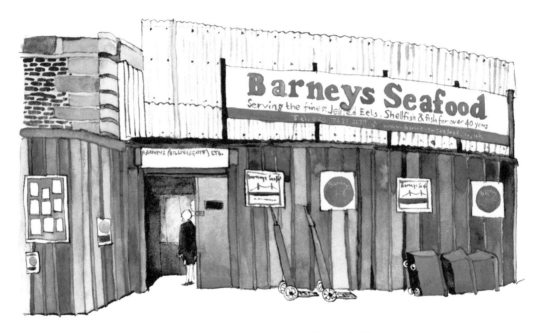

Barneys Seafood, Chamber Street, Tower Bridge

TUCKED UNDER a railway arch near the Tower of London, this legendary eel, fish and shellfish shop attracts hordes of East Enders, eager for eels freshly boiled on the premises. The founder, Barney Gritzman, was the brother of Solly Gritzman, owner of the famous Tubby Isaac's Jellied Eel stall. He opened up his business before World War II and it has been run by the Button family since 1970, trading under the name of Barneys.

THIS SHOP was founded by Steve Davies in 1976 but its origins go back to his great-great-grandfather who ran a market stall selling fish in 1870. Davies and Sons proudly sports a traditional glazed frontage with serif lettering on a cobalt blue ground which is much admired locally. Still run by the Davies family, this is Walthamstow's last fishmonger and, as a regular customer, I can personally testify that they are indeed 'purveyors of quality fresh fish', just as the fascia declares.

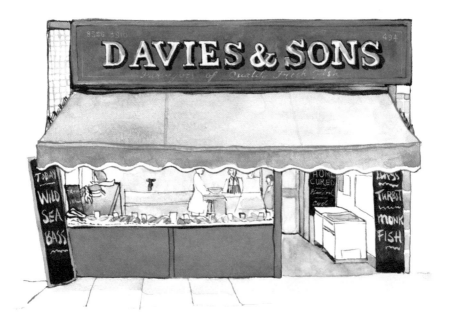

Davies and Sons, Hoe Street, Walthamstow

THE FISH PLAICE (*opposite*) was run by Andy and Nitsa from 1974, retaining the original decor in pristine condition and enjoying loyal customers for over forty years. Andy's father owned a fish and chip shop, as did his uncles, so he inherited a thorough understanding of the business. The Fish Plaice was the closest chippy to the site of London's first ever fish and chip shop, which was opened by Russian Jewish immigrants nearby in Cleveland Way in the nineteenth century. They originated the idea of serving fried fish and chips together from the same shop.

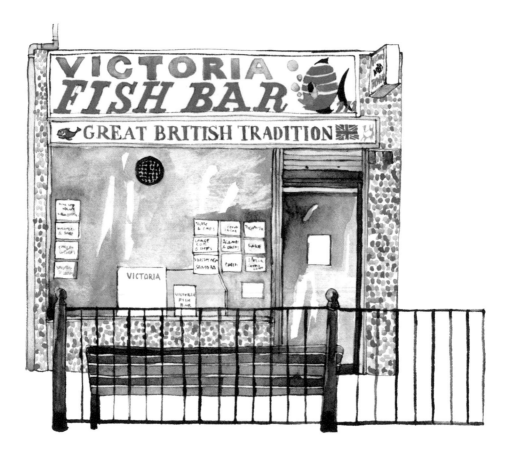

Victoria Fish Bar, Roman Road, Bethnal Green

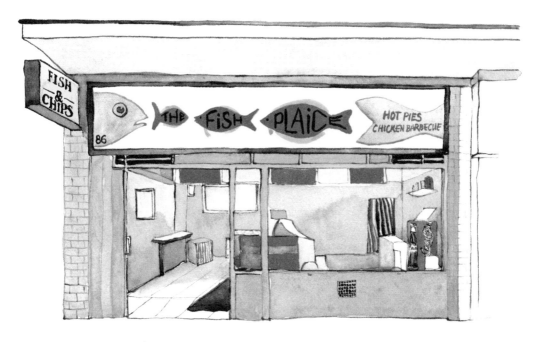

The Fish Plaice, Cambridge Heath Road, Bethnal Green

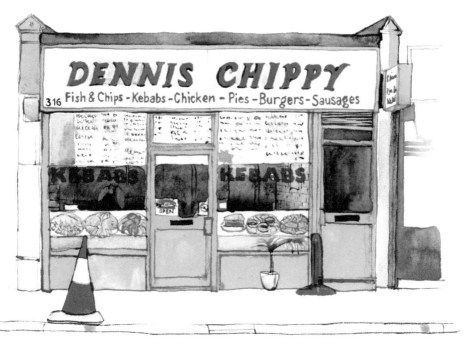

Dennis Chippy, Lea Bridge Road, Leyton

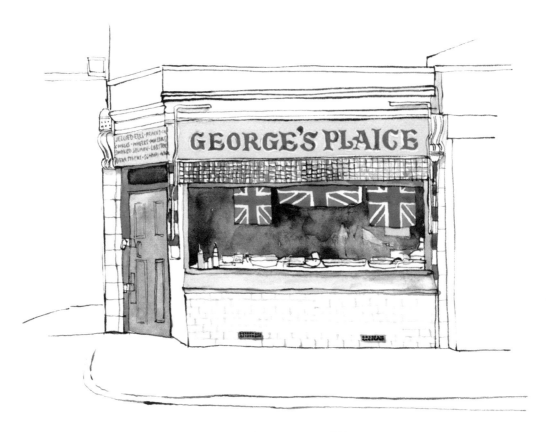

George's Plaice, Roman Road, Bow

THERE WAS a fishmonger on this site from 1898 but now George's Plaice is just a fond memory on Roman Road in Bow. For thirty-six years from 1982, it was managed by the redoubtable Tom Disson. Tom took over from his brother-in-law George, who ran it from 1975 and gave his name to the shop.

When I was cycling past, the seventies lettering in pink, contrasting with tiling in blue and white, above an open frontage with trays of shellfish gleaming on the steel counter caught my eye. The Union Jacks add to the patriotic and celebratory air of this beloved shrine to fresh fish.

ESTABLISHED IN 1958, the owners of this fish and chip shop near the British Museum in Holborn have wisely retained the original red formica counter and booth seating. I am particularly fond of the Playbill lettering and whimsical fish on the signage complemented by the azure mosaic below.

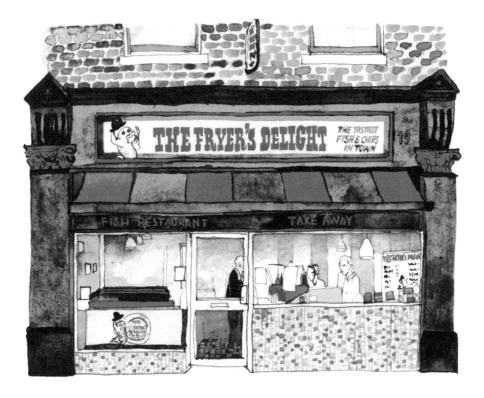

The Fryer's Delight, Theobalds Road, Holborn

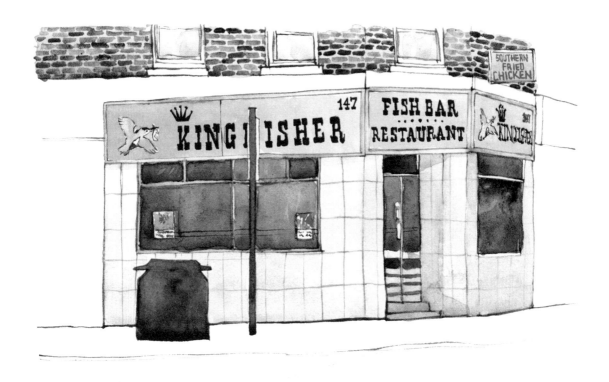

Kingfisher, Homerton High Street, Clapton

JONATHAN NORRIS has only run his fresh fish business since 2005, graduating to the current premises next to Victoria Park (*opposite*) in 2009 from a stall in Tachbrook Street Market in Pimlico. Yet he now has another in Tufnell Park as well as the original market stall in Pimlico.

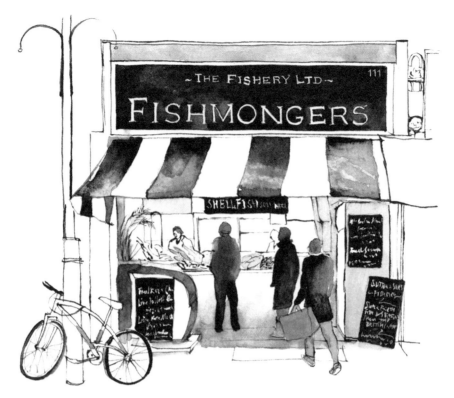

The Fishery, Stoke Newington High Street, Stoke Newington

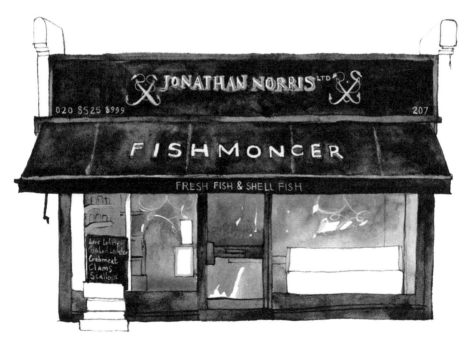

Jonathan Norris, Victoria Park Road, Victoria Park

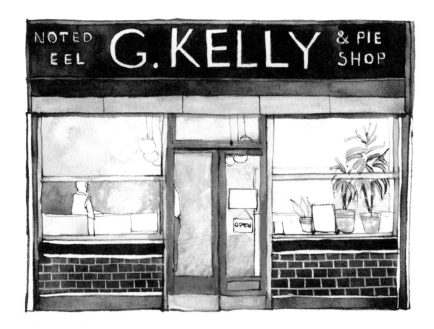

G. Kelly, Roman Road

IN 1937, George Kelly took over this eel and pie shop in Roman Road which opened in the early twenties. Then Bill Kingdon, his brother-in-law, bought the shop in the mid-fifties and it is still run by his descendants. Today, owner Sue Venning make pies from the same recipe handed down through four generations, including the celebrated fruit pies.

G KELLY'S eel and pie shop on Bethnal Green Road attracted my attention with its emerald tiles and three-dimensional chrome letters. The interior has been unchanged in a century, with traditional tiling and marble tables on cast-iron stands. Connected only by genealogy, both this shop and G Kelly in the Roman Road have been run by different branches of the family since the fifties, yet they owe their common origin to Samuel Kelly, who opened up in Bethnal Green in 1915. Senior customers, some well into their nineties, remember when you could pick a live eel for your dinner from a bucket outside.

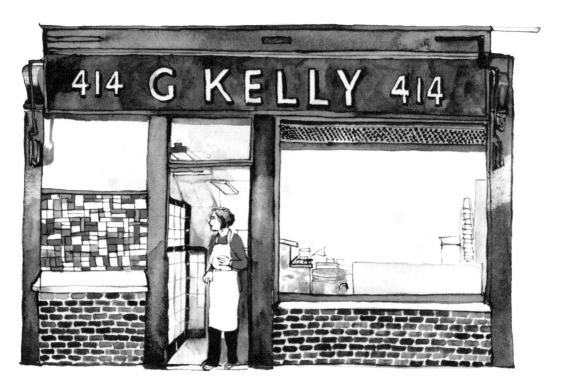

G Kelly, Bethnal Green Road, Bethnal Green

OPENED IN the thirties by Lionel Manze, this eel and pie shop in Walthamstow High Street has thankfully managed to preserve its fine gilded glass signage, tiling and wooden booths, even if the antique ornamental till was stolen in 2017. Lionel was the brother of Michele Manze, who came from Ravello in Italy in 1878 as a child and opened the first Manze family eel and pie shop in Tower Bridge Road in 1902, taking over from Robert Cooke, who traded there from 1891. By 1930, there were fourteen shops with the Manze name and, although the Walthamstow shop is now owned independently, Manzes in Tower Bridge Road and Deptford are still run by the family.

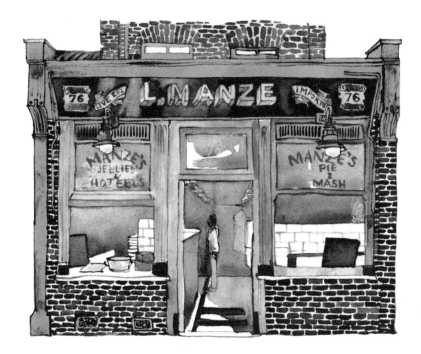

L. Manze, High Street, Walthamstow

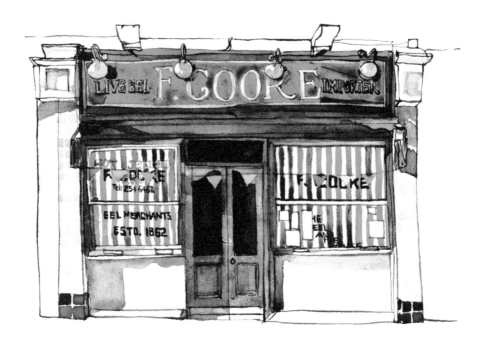

F. Cooke, Broadway Market

ROBERT COOKE opened his first eel and pie shop in Brick Lane in 1862 and his family still run shops in the East End to this day. This one opened in Broadway Market in 1900 and is distinguished by its fine glazed interior with marble table tops, wooden benches and the old clock behind the counter, commissioned by Robert in 1911. The exterior boasts elegant gold swash lettering on a Brunswick green ground painted behind a glass fascia. Note the sills and panels in marble, sitting below wide sashes that are opened in summer. Robert Cooke's grandson Bob runs this shop today, while his brother Joseph runs the one in Hoxton Market and both continue to make pies to their grandfather's recipes.

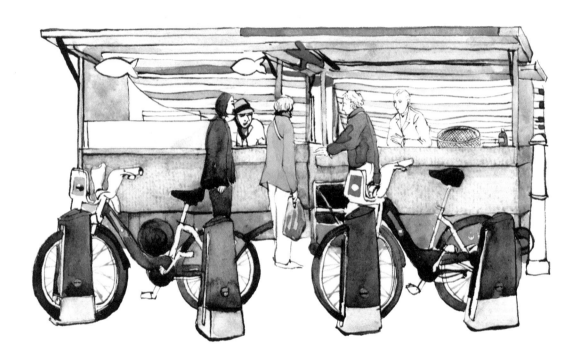

Downey Brothers, Globe Town, Mile End

TUBBY ISAAC'S Jellied Eel stall was in Petticoat Lane for ninety-four years, run by four generations of the same family. When Tubby emigrated to America in 1939, his nephew Solly took over and ran it until 1975. Unfortunately, Solly got into a feud with his brother Barney who opened a rival jellied eel stall across the road. Yet after Solly died, Barney supplied Tubby Isaac's until it closed in 2013. By chance, I arrived on the very last day of Tubby Isaac's, when there was no time left to do a painting, so I had to work from a photograph.

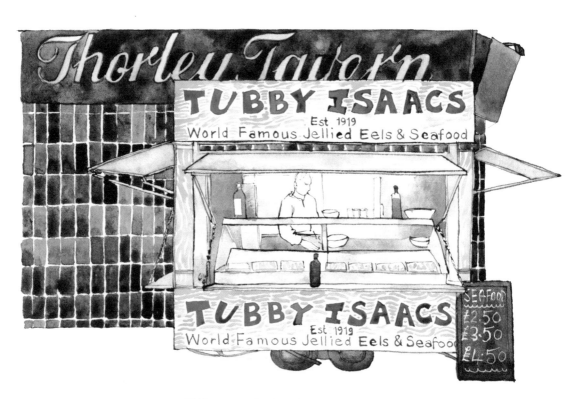

Tubby Isaacs, Goulston Street, Aldgate

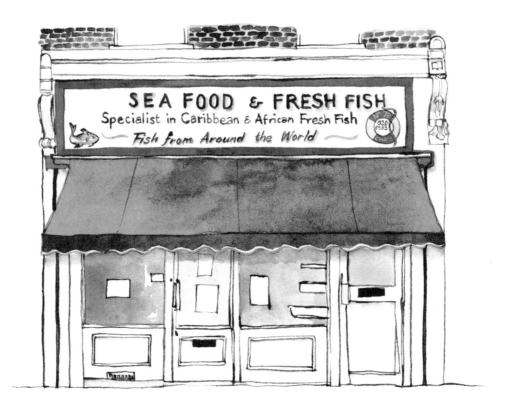

Sea Food & Fresh Fish, Chatsworth Road, Clapton

GREENGROCERS

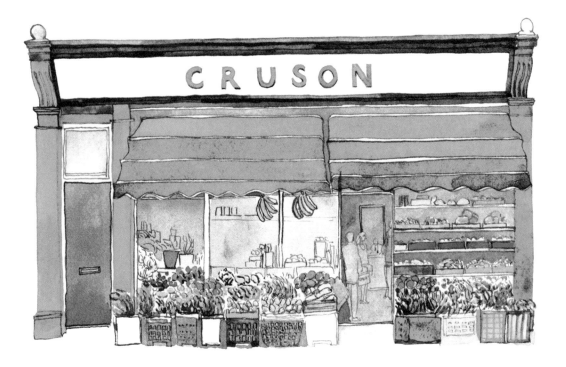

Cruson, Camberwell Church Street, Camberwell

CRUSON IS a local institution run by Maria and Aris, a Cypriot couple who took it over in 1971. They sell traditional fruit, vegetables and flowers, alongside a variety of exotic specialities – yoghurts, figs, dates and spices.

Despite nearby supermarkets, savvy customers remain loyal to Cruson, keen to try new things and supportive of a shop committed to using the minimum amount of plastic.

MORE DELICATESSEN than greengrocer, this Soho establishment was opened in 1944 by Lina, a woman from Genova. Since then, it has established a formidable reputation for quality imported Italian produce sold alongside freshly made pasta and sandwiches. The recent refurbishment retains the historic detailing, while refitting the interior in a complementary modern design. By virtue of its distinctive mint green paintwork, glazed tiles and natty typography, Lina Stores declares its presence with panache in the narrow streets of Soho.

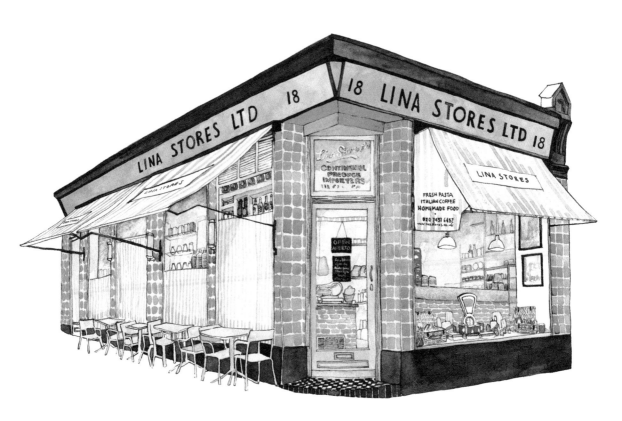

Lina Stores, Brewer Street, Soho

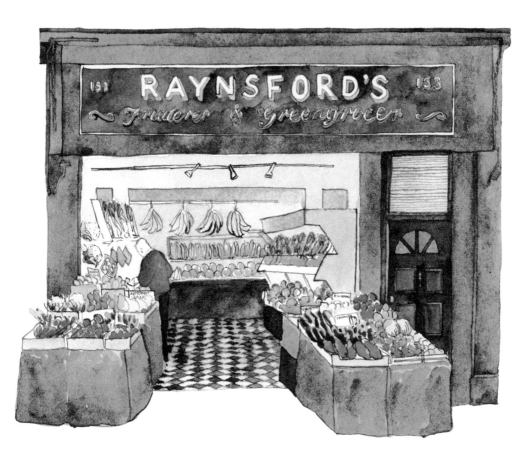

Raynsford's, Battersea High Street, Battersea

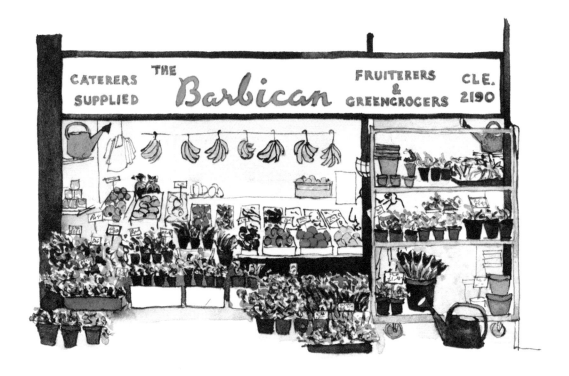

The Barbican, Goswell Road, Barbican

THIS FLORIST in Plaistow (*opposite*) has been run by the Sewell family since the thirties, and is celebrated for its ingenious window displays. I painted it during the Tour de France when the window featured two bicycles adorned with flowers beneath strings of bunting – all in yellow and embellished with Union Jacks in support of our riders. The wide pavement allows for a cheerful array of bedding plants outside to greet customers before they enter the fragrant interior filled with buckets of cut flowers.

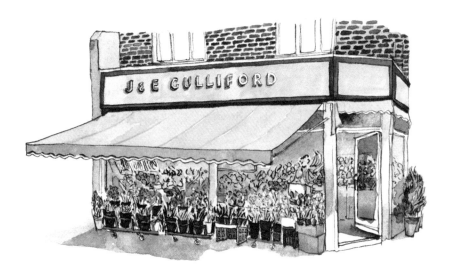

J & E Gulliford, Highbury Park, Highbury

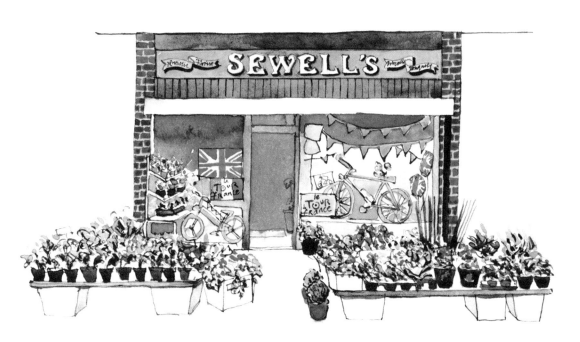

Sewell's, Plaistow Road, Plaistow

Leila's Shop, Calvert Avenue, Shoreditch

THIS GREENGROCER in Calvert Avenue was opened by Phoebe and Alf Raymond in 1900 in the newly built Boundary Estate – Britain's first council estate – and was run by the family until 1966. In 2002, Leila McAlister re-opened it as a greengrocer, stocking seasonal fruit and vegetables from independent and small growers, alongside fresh bread, cheese and dry goods. Beneath the wide brown canopy at the front, you can rely upon discovering the East End's most beautiful display of produce and this ever-changing stock forms the basis of the menu for Leila's Café next door.

DAIRY SHOPS

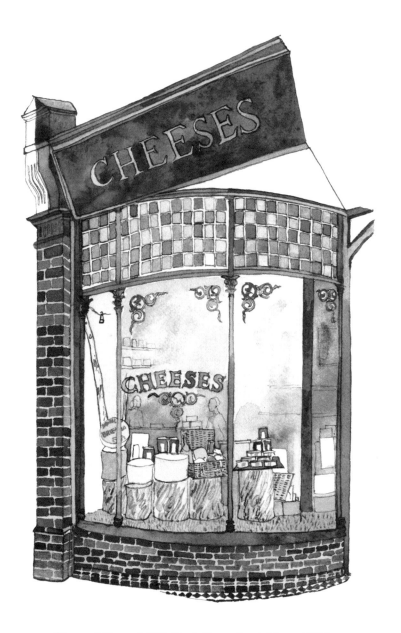

Cheeses of Muswell Hill, Fortis Green Road, Muswell Hill

ALTHOUGH ELLIOTT'S DAIRIES was converted to flats years ago, I am grateful that the frontage stands intact with the text 'Dairy, Eggs, Butter & Cream' above the left-hand door and the tiny sticker of a milkman just visible in the window above the right-hand door.

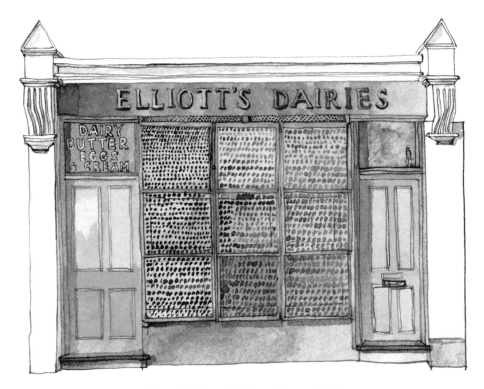

Elliott's Dairies, Shacklewell Lane, Dalston

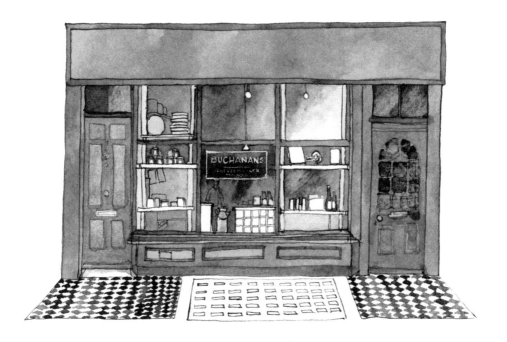

Buchanans Cheesemonger, Porchester Place, Marble Arch

SPECIALIST CHEESE shops are on the rise in fashionable areas of London, many opened by ex-restaurateurs, such as this one founded by Rhuaridh Buchanan. The ubiquity of bland industrially produced cheese has inspired a revival in artisan varieties, creating an eager market for the enormous variety of regional cheeses from small producers in Britain and mainland Europe.

THIS IS another of the new cheese shops, offering craft beer as a complement to cheese – the 'froth' and the 'rind' as they term it. Both may be enjoyed in the café on the premises.

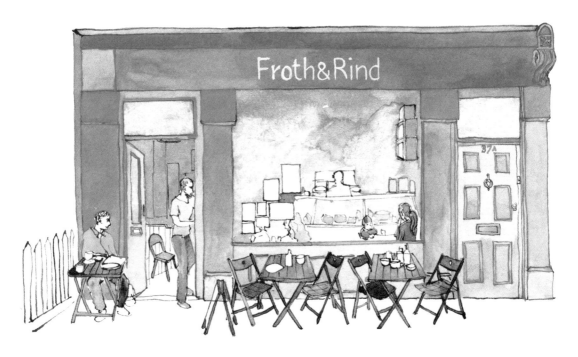

Froth & Rind, Orford Road, Walthamstow

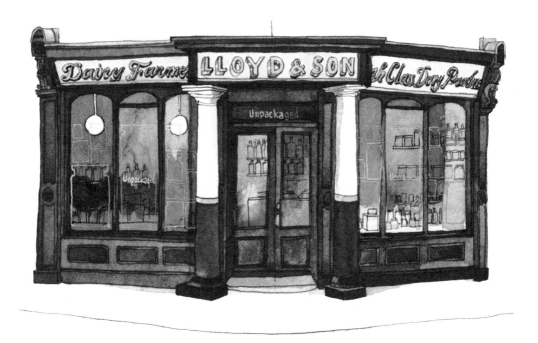

Lloyd & Son, Amwell Street, Clerkenwell

BUILT IN 1823, this shop was originally occupied by a seller of olive oil and imported groceries. The frontage was remodelled for an auctioneer in 1865, acquiring the Doric portico that still forms a decorative support for the curved corner entrance today. Lloyd & Son opened in the twenties with 'Dairy' emblazoned across the top of the building and a display of giant milk bottles in the window.

The family ran the dairy through three generations until they closed in the nineties. The shop has had several incarnations since then and is currently a hairdressers. Fortunately, Lloyd & Son's antique gilded and painted glass signage – which makes this place a cherished local landmark – is preserved and protected.

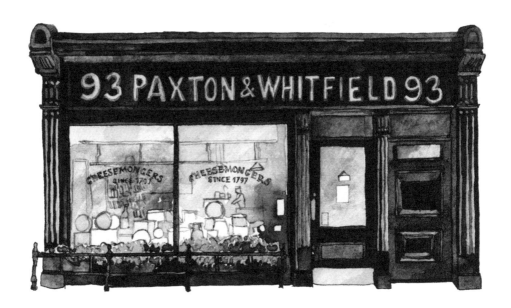

Paxton & Whitfield, Jermyn Street, St James's

CHEESEMONGERS TO Queen Victoria and holders of a string of Royal Warrants of Appointment, Paxton & Whitfield was founded in 1797, moving to Jermyn Street in 1896. Now in their third century of cheesemongering, they are proud to offer 'exceptional cheeses' and cherish the dignified black and gold shopfront that proclaims their illustrious history.

CHEMISTS

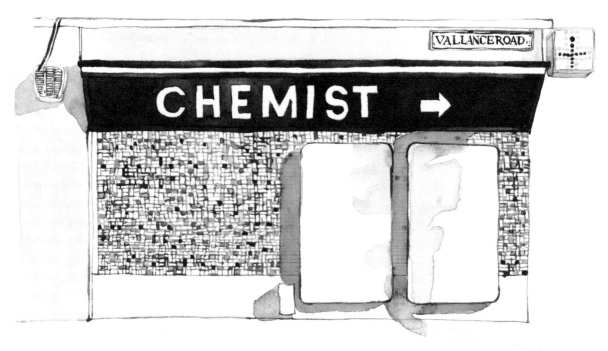

Chemist, Vallance Road, Whitechapel

THIS CURIOUS single-storey shop on the corner of the Whitechapel Road was the site of a three-storey building that housed an apothecary and a surgeon in the nineteenth century, reflecting the proximity of the Royal London Hospital. Rebuilt as a chemist after bomb damage in World War II, it acquired large shop windows on both sides in the fifties. Chemists J. Liff traded here until the sixties when another chemist, Beck & Sherman, took over. They boarded over the windows on the Vallance Road side and installed the mosaic tiling that first caught my attention, creating a dynamic contrast with the bold type and arrow pointing around the corner to the Whitechapel Road.

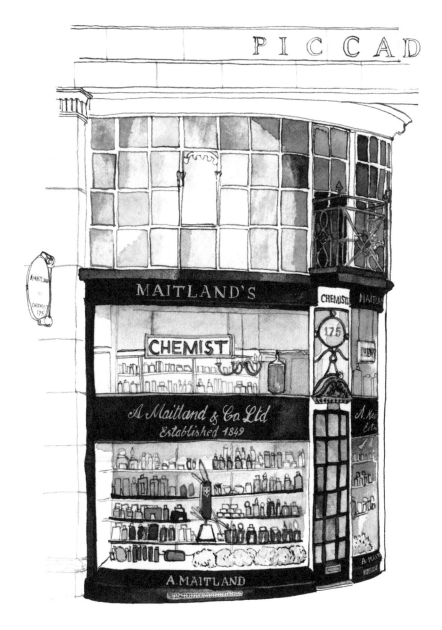

A. Maitland & Co, Piccadilly, St James's

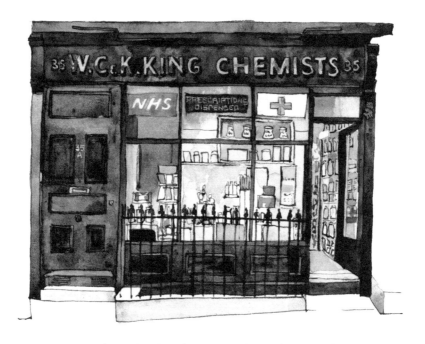

W.C&K. King Chemists, Amwell Street, Clerkenwell

W.C & K. KING has been on Amwell Street since 1843, retaining its Victorian fascia and Edwardian fittings. Most of the shops in this row, known as Thompson's Terrace, were purpose-built in the eighteen-twenties as part of the New River and Lloyd Baker estates. Like Lloyd & Son, just down the street, they are a rare survival.

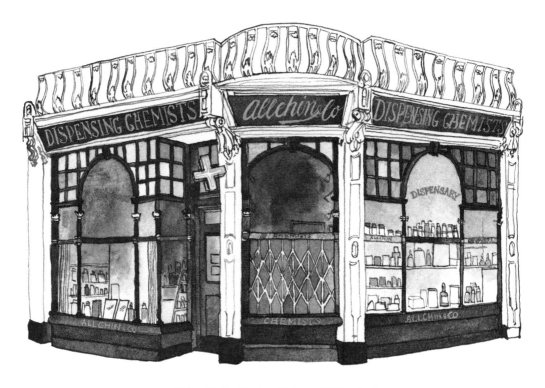

Allchin & Co, England's Lane, Belsize Park

THE SHOP was opened by Alfred Allchin, a nineteenth-century pharmaceutical chemist and creator of Allchin's Smelling Salts. Still an independent pharmacy, the current owners retain the name of the business but have recently chosen to conceal the original signs with their elegant gilded lettering behind new plastic ones.

ESTABLISHED IN 1846 and serving this quiet corner of Belgravia for over one hundred and fifty years, Walden Chymist is still an independently run pharmacy. The shopfront is Grade II listed and Lata Patel, who has run the business since 1980, is proud of her splendid facade with its old gilded letters and original architectural detailing.

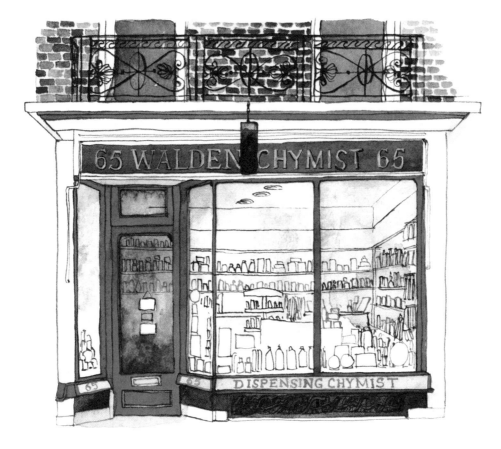

Walden Chymist, Elisabeth Street, Belgravia

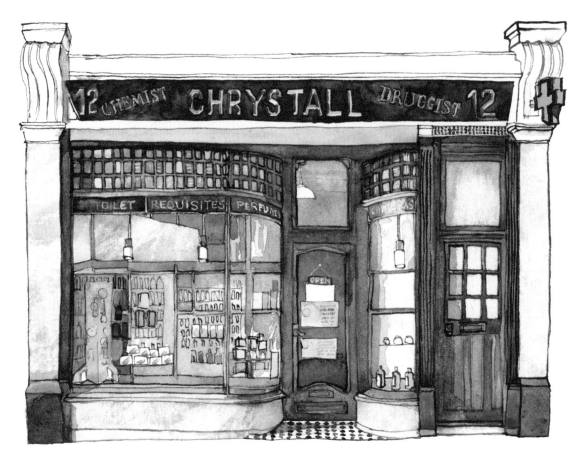

Chrystall, The Broadway, Woodford Green

CHRYSTALL HAS been a chemist for over a century. Situated close to the Edwardian Monkhams Estate in Woodford on the border with Essex, the surrounding suburb grew up as the railway extended from London in the nineteenth century. This is now the last Edwardian frontage left on The Broadway, a run that originally consisted of all the necessary small shops including a fishmonger and an ironmonger.

LAUNDERETTES

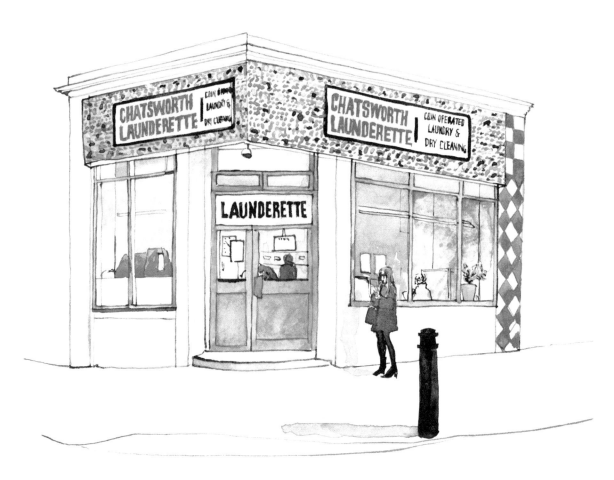

Chatsworth Launderette, Chatsworth Road, Lower Clapton

CHATSWORTH LAUNDERETTE commands a corner site, serving coffees and offering chairs outside for customers to socialise on sunny days. This place offers a valuable service to local residents who need extra washing space or a service wash, as well as to those who are more recent arrivals with no access to a machine, and to anyone with items too large for a domestic washer and dryer. Many launderettes, including this one, benefit from stylish fifties and sixties interior design that has remained popular through the decades.

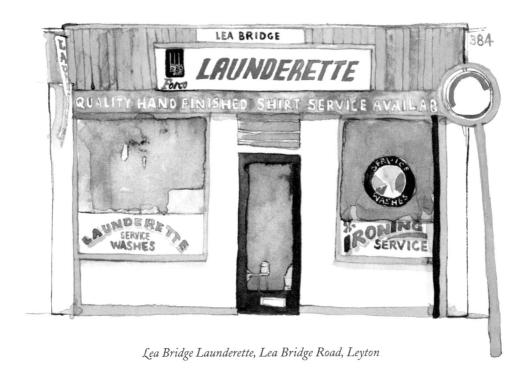

Lea Bridge Launderette, Lea Bridge Road, Leyton

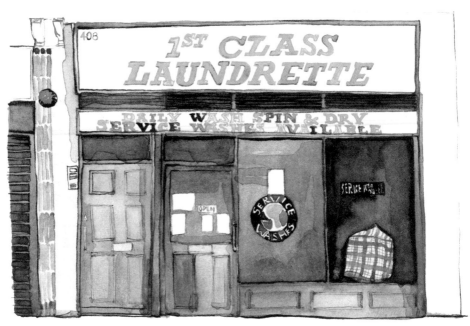

1st Class Laundrette, Kingsland Road, Kingsland

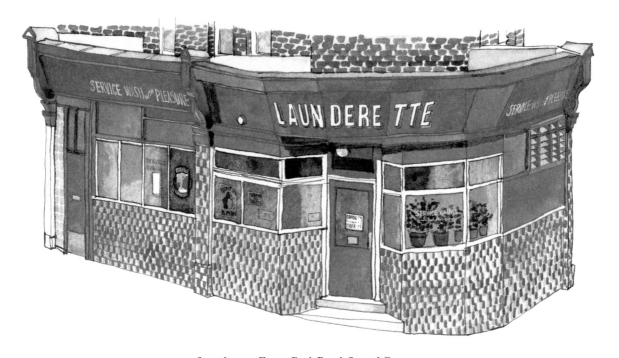

Launderette, Ferme Park Road, Stroud Green

THIS BUSY launderette is distinguished by its gleaming blue tiling, idiosyncratically placed white lettering and magnificent pot plants. An old postcard I found revealed that this corner was formerly the Ferme Park Post & Telegraph Office, superseded by Williams Brothers' Grocers and Provisions Store.

DEEP CLEAN Launderette opened as Westcotts Laundry in 1957 and continues to serve the residents of Walthamstow today. I am drawn to its heartwarming yellow fascia and matching washing machines, enhanced by lustrous tiling and upbeat typography.

In the nineteenth century, there were a great many small shops in Beulah Road – dairies, butchers, bakers, a fruiterer, a fishmonger, three drapers, a stationer, a bootmaker, a coachbuilder and an upholsterer.

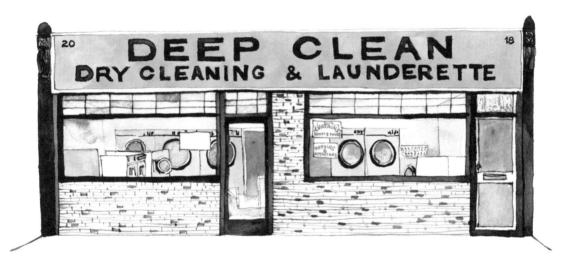

Deep Clean, Beulah Road, Walthamstow

IRONMONGERS

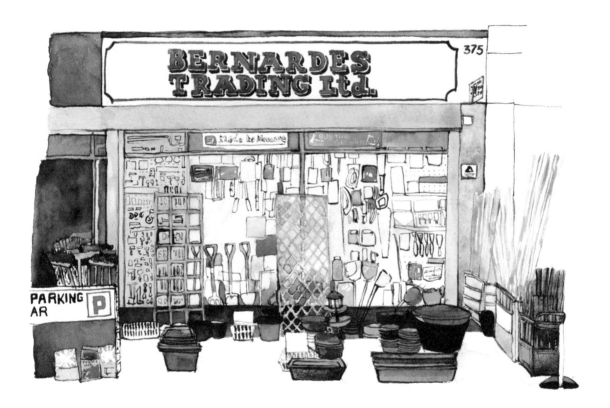

Bernardes Trading, Barking Road, Plaistow

THIS IS a third-generation family business run by Ian and Janet Bernardes. Ian's grandfather Jack founded the shop in 1908 and Ian worked there for more than half a century. At the end of 2018, Ian and Janet chose to retire and close the ironmongers along with their doll's house shop next door. Although the interior was lined from floor to ceiling with rows and rows of shelves containing all manner of hardware, fixtures and fittings, their ability to find things was legendary.

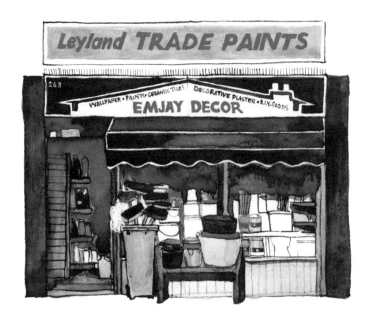

Emjay Decor, Bethnal Green Road

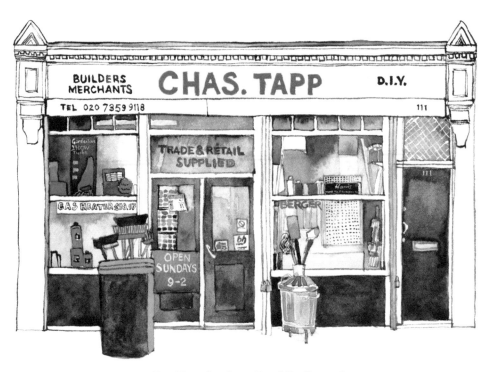

Chas. Tapp, Southgate Road, De Beauvoir

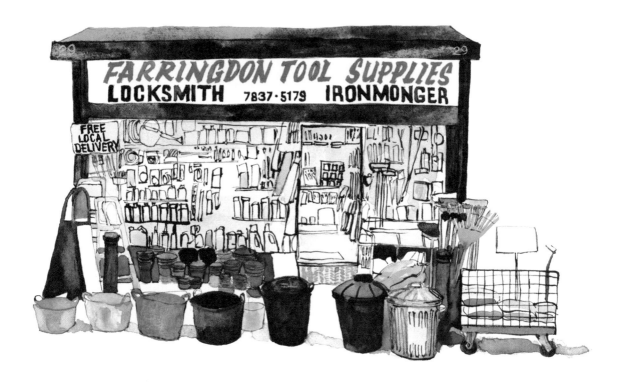

Farringdon Tool Supplies, Exmouth Market, Clerkenwell

ESTABLISHED IN 1908, Farringdon Tool Supplies offers locksmith services as well as a wide range of hardware. Although the awning is usually extended to protect the display of goods, covering the fascia, I painted the frontage with the sign visible because I like the lettering. In 1910, this address was listed as a butcher, with an ironmonger two doors away, so it is likely that the business moved premises in the early days. In the first decades of the nineteenth century, Exmouth Market was all small trades, including a cabinetmaker, a shoemaker, carvers, a looking-glass maker and a printer. Today, Farringdon Tool Supplies is the last evidence of this ancient craft tradition in Clerkenwell.

IN THE eighteen-nineties, the two shops that now house Bradbury's Ironmongers were listed as J. Whitfield, Dyer, and W. Grant, Carver & Gilder. In 1906, they were owned by G. Keagle, Ostrich Feather Manufacturer, and J. Bassett & Son, Funeral Directors.

Albert Bradbury, Ironmonger, was first listed at these premises in 1956 and the continued presence of this useful hardware shop, despite the changing fortunes of the street over the decades, is testament to the necessity of the trade.

Bradbury's, Broadway Market, London Fields

WAKEFIELD IS a third-generation family-run business (*opposite*) who provide expert advice and a wide range of stock. I have bought a great many items here and have encountered customers who have been loyal to this temple of hardware for over fifty years.

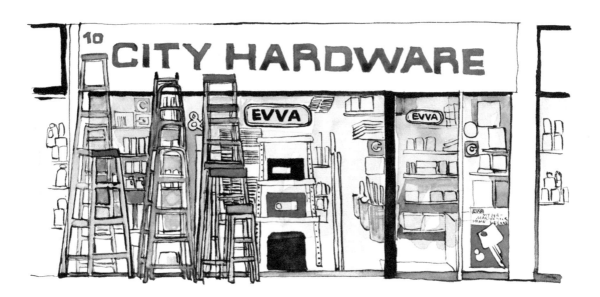

City Hardware, Goswell Road, Barbican

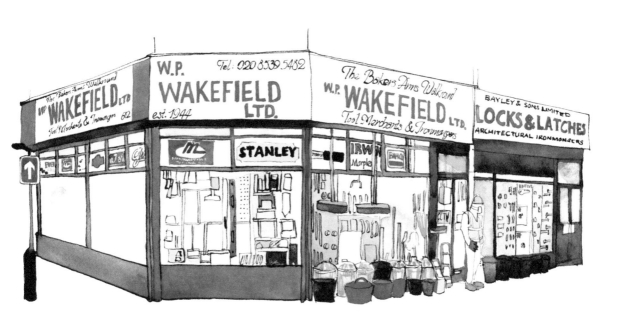

W.P. Wakefield, Lea Bridge Road, Leyton

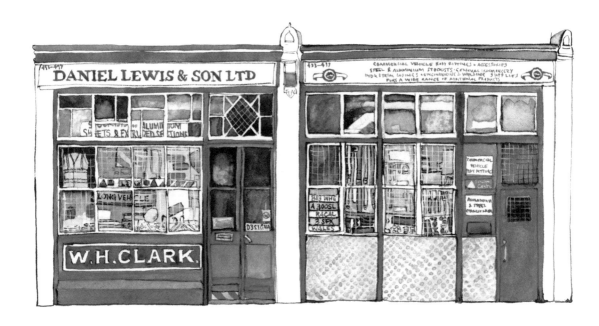

Daniel Lewis & Son, Hackney Road, Cambridge Heath

THIS WAS London's oldest ironmonger, originally founded by Presland & Sons in 1797, purpose-built as a shop and factory. In the eighteen-nineties it became W. H. Clark Ltd. Then Daniel Lewis, who joined as a junior in 1948, took on the business in 1971 and continued trading under the Clark name. Daniel's son David worked there from 1992 and renamed it after his father in 2002. In 2012, he was forced to close when council regulations prevented customers parking and restricted deliveries. Since I painted it, the shopfront has been replaced by a new replica which is a close copy of this Georgian original. Until the end, the original interior with all its fittings and the manufacturing workshops at the rear survived, revealing how the business evolved, supplying first the coach building industry and then metal fabricators, architects and sculptors.

FRANK ISON'S Ironmongery & Oil Store opened in the late nineteenth century and traded as a family business until 2004. There was once a stable at the rear built in 1902 by Frank Ison. Walthamstow residents are fond of the gilded signage, which is a local landmark and has been left untouched by the estate agents who now own it. The Walthamstow Village Window Gallery operates from the shop window where I held an exhibition of a hundred of my shopfront paintings, including this one of Frank Ison.

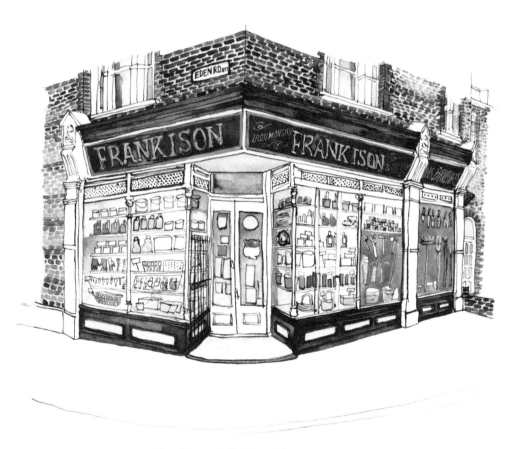

Frank Ison, Orford Road, Walthamstow

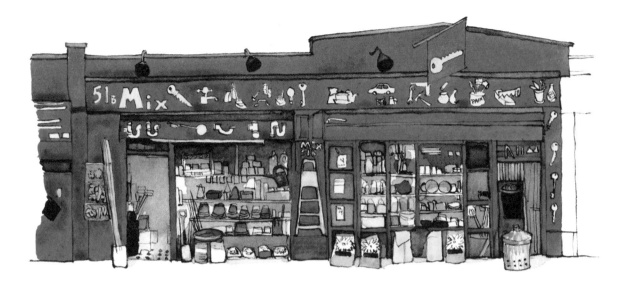

Mix Hardware, Blackstock Road, Finsbury Park

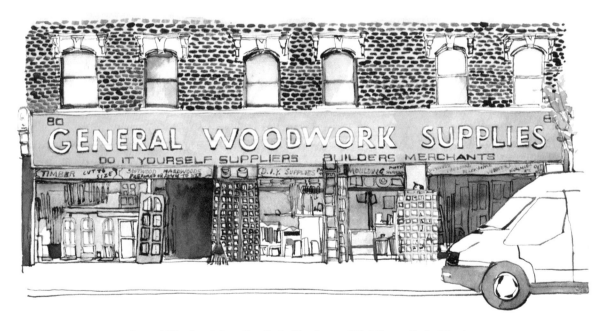

General Woodwork Supplies, Stoke Newington High Street, Stoke Newington

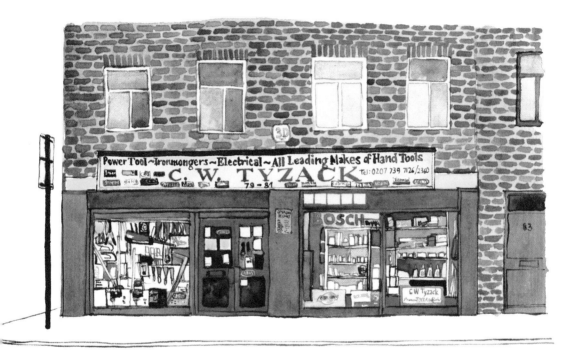

C. W. Tyzack, Kingsland Road, Shoreditch

CECIL TYZACK founded his business in 1936 and his shop on the Kingsland Road is still open, although it is no longer owned by the Tyzacks. The family name retains its reputation as a hand and power tool manufacturer as 'Tyzack Machine Knives'. Cecil was born into a branch of the Tyzack family of sawmakers who came to London from Sheffield in 1839. They manufactured and sold tools from a succession of shops in Old Street until the beginning of this century. Today vintage Tyzack tools are much collected.

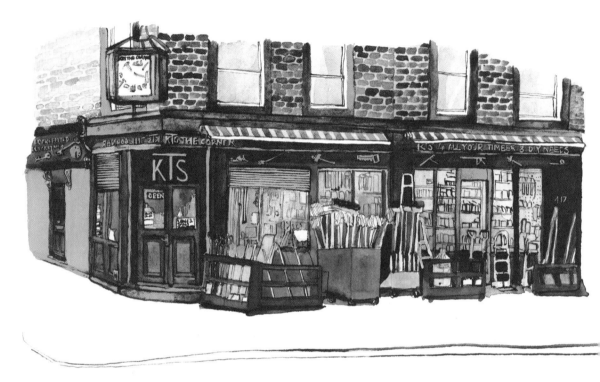

KTS The Corner, Kingsland Road, Dalston

I HAVE included only a fraction of the intricate hand-carved fascia lettering and signage which continues across the side of the building along Englefield Road. This bravura frieze of pictograms depicting Plumbing & Electrical, Joinery, Keys Cut, Gardening and Timber Cut-to-Size, and the three-dimensional clock hanging above the door, were designed and made by Tony O'Kane, the owner. Although it is widely believed the initials stand for Kingsland Timber Service, in fact Tony named the business after his three children, Katie, Toni and Sean. I often return to this favourite shop on the Kingsland Road to admire the magnificent pavement display of brooms, mops and spades, as well as the innumerable small tools in the windows.

KAC HARDWARE was established on Church Street in 1954, replacing J. Weeden Stores, an oil shop since 1885. Although many of the older shops in this area have gone, KAC Hardware persists. Observe the words in the leaded panels of the transom lights declaring the available hardware services, as well as the hanging key.

KAC Hardware, Church Street, Stoke Newington

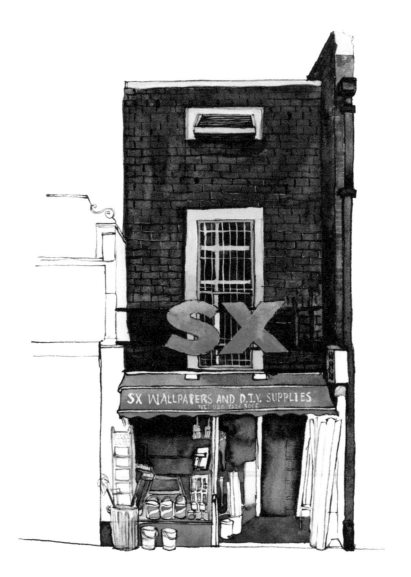

SX, Essex Road, Islington

PAPER GOODS

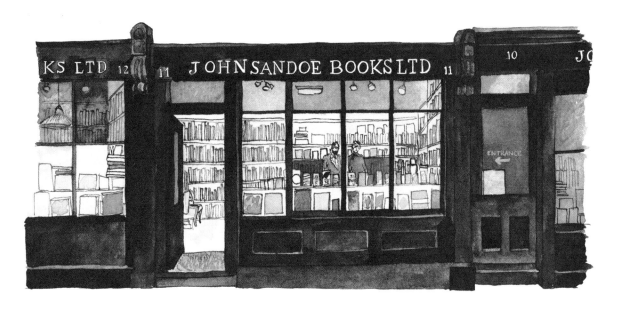

John Sandoe Books, Blacklands Terrace, Chelsea

FOUNDED IN 1957, only three years after the end of rationing and when Chelsea was still scruffy, this local bookshop now spans three floors of three Georgian shops with an astonishing selection of titles crammed into every available space. Since the King's Road became dominated by upmarket chain stores, this independent bookshop has become a popular destination for those hungry for literary sustenance. Of London's many small bookshops, I chose to paint John Sandoe because of its graceful eighteenth-century shopfront.

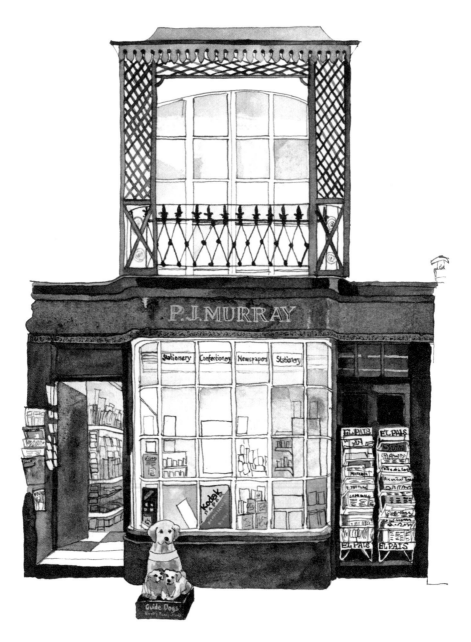

P. J. Murray, Woburn Walk, Euston

P. J. MURRAY (*opposite*) sits in a parade of shops developed by Thomas Cubitt in Greek Revival Style in 1822, originally called Woburn Buildings. Each features a flattened bow window with parallel doors on either side, and is separated from its neighbour by twin pilasters. In this quiet neighbourhood close to Euston and Kings Cross, P.J. Murray stocks a range of international newspapers, catering both for travellers and foreign students as well as local residents.

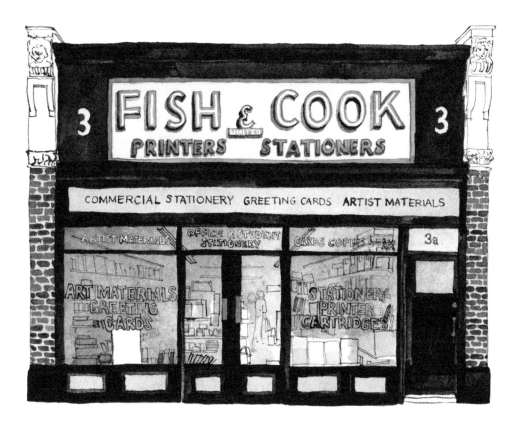

Fish & Cook, Blackstock Road, Finsbury Park

A STATIONERS since the fifties, Fish & Cook sells stationery and art materials behind a black frontage crowned by a fascia with three-dimensional fuchsia pink lettering.

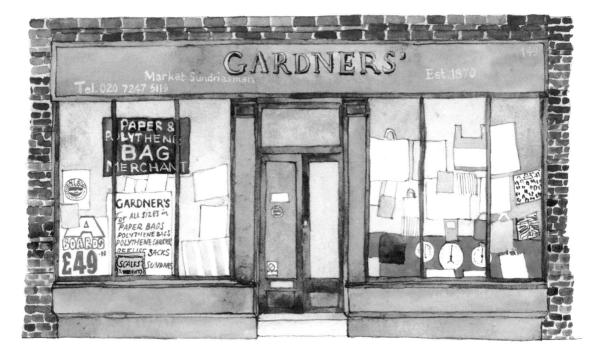

Gardners', Commercial Street, Spitalfields

GARDNERS' IS the longest established family business in Spitalfields. Paul Gardner's great-grandfather James Gardner began trading here as a scalemaker when the Peabody Building was first built in 1870. Gardners' expanded to supply paper bags to greengrocers and countless other small local traders, earning a reputation for London's cheapest paper bags. Paul has run the shop since he was seventeen without a day off and keeps a collection of family memorabilia behind the counter. This includes the nineteenth-century family bible, account books from the eighteen-eighties and his father Roy Gardner's designs for greengrocers' labels. As founder of the East End Trades Guild, Paul is universally respected in the East End for his moral leadership, delivering petitions to Downing Street protesting the escalation of rent and business rates that have driven many small shops to the wall.

A SECOND-GENERATION family business, this antiquarian bookseller opened in 1968 in one of the oldest shops in Chiswick, built in the seventeen-nineties. Previously, the shop was a collecting depot for local laundries. The Grade II listed Georgian shopfront features a bow window flanked by two doors, one with a fanlight. As well as selling books and prints locally and online, they supply books as properties for films and work with Historic England in the recreation of period libraries.

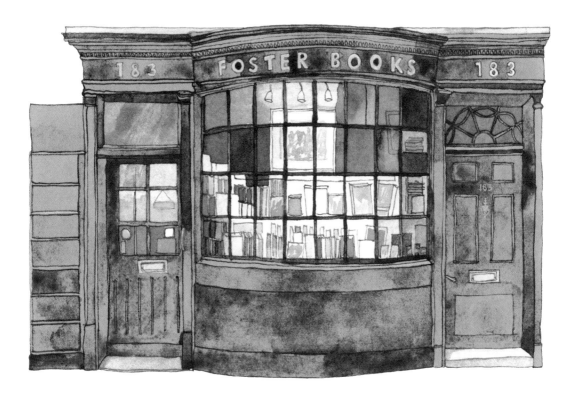

Foster Books, Chiswick High Street, Chiswick

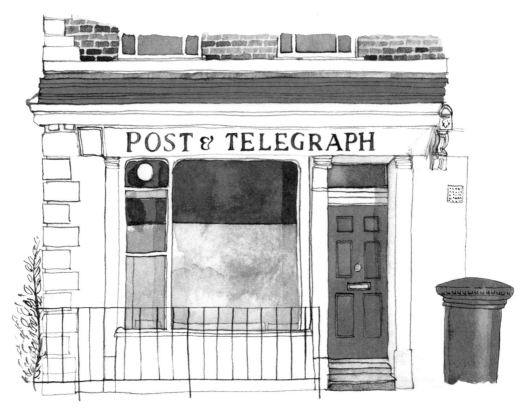

Post & Telegraph, Cadogan Terrace, Victoria Park

NO LONGER a shop, I have painted this former Post & Telegraph Office shopfront near Victoria Park to represent the innumerable small Post Offices that once existed across London and which are now gone. The homogenous plastic signage of those that survive cannot compare with the lettering on this shop and I was delighted to see that the residents had left it. I grew up in a village where the Post Office was so small you had to crouch to get through the front door and which also featured fine signwriting. The closure of Post Offices has been rightly contested because they offer an invaluable community resource and meeting place in both urban and rural areas.

ACKNOWLEDGEMENTS

MY THANKS ARE DUE to Friederike Huber for her design, Vicky Stewart for her research, The Gentle Author for encouragement, and my publishers Batsford and Spitalfields Life Books for their support. Additionally, I am grateful to Walthamstow Village Window Gallery and to Townhouse, Spitalfields, who exhibited my watercolours. I would like to thank the shopkeepers for their inspiration.

First published in the
United Kingdom
in 2019 by Batsford
43 Great Ormond Street
London WC1N 3HZ

An imprint of Pavilion Books Group
Published in association with Spitalfields Life Books

Design by Friederike Huber

ISBN: 9781849945622

A CIP catalogue record for this book is available from
the British Library.

10 9 8 7 6 5 4 3 2 1

Reproduction by Mission Productions, Hong Kong
Printed by Toppan Leefung Printing Ltd, China

This book can be ordered direct from the publisher
www.pavilionbooks.com or try your local bookshop.